Silver: the Traditional Art of Oman

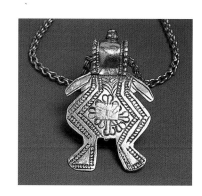

This work is produced with the kind assistance of

William R Asprey Esq

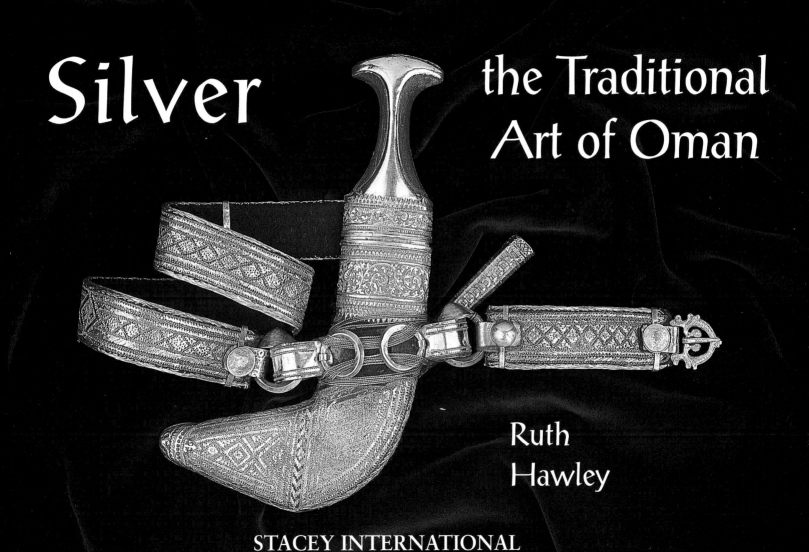

Silver

the Traditional Art of Oman

Ruth Hawley

STACEY INTERNATIONAL

Silver: the Traditional Art of Oman
by Ruth Hawley

Published by Stacey International,
128 Kensington Church Street, London W8 4BH
Tel: +44 20 7221 7166
E-mail: enquiries @stacey_international.co.uk

Editor: John Wheelwright
Design: Jo Cotter & Kitty Carruthers
Repro: Parker Baines, London
Printing and Binding: Oriental Press, Dubai

British Library Cataloguing in Publication Data.
A catalogue record for this book is available from
British Library.

ISBN: 1 900988 27 5

CONTENTS

Map of oman 7

Introduction 9

Chapter 1 : General History 11

Chapter 2 : Early Influences 17

Chapter 3 : Purposes of Jewellery 23
 Amuletic 23
 Social 27

Chapter 4 : Materials 31
 Metals 31
 Stones 36

Chapter 5 : Techniques 39

Chapter 6 : Design 43

Chapter 7 : The Maria Theresa Thaler 47

Chapter 8 : Everyday Objects of Silver 51

Chapter 9 : Jewellery 55
 Necklaces 55
 Anklets and Bracelets 59
 Ear-rings 62
 Hair and Clothing Decorations 64
 Chains 65
 Rings 66

Chapter 10 : Weapons 69
 Khanjars, Knives and Swords 69
 The Shihuh Axe (Jerz) 74
 Guns 75

Chapter 11 : Dhofari silver 79
 Amulets 84
 Necklaces and Beads 84
 Bracelets and Anklets 86
 Ear-rings 88
 Hair Decorations 88
 Rings 91
 Ornamentation Worn by Men 92

Bibliography 95

Index 97

Acknowledgements

I should like to express my gratitude to the people who helped me with specific textual points on my earlier book *Omani Silver* (Longmans, 1978), on which much of this book is based, and to H.H. Sayyid Faisal bin Ali Al Said for the loan of the photographs and for the material on the Maria Theresa Thaler, Sayyida Maryam Zawawi, Mrs Asya Ahmed al Lamki, Ahmed bin Abdul Rahman Alhaag Hassan (goldsmith in the Matrah souk), Khan Mohammed of Abu Afaf Jewellers Matrah, Maqbool of Matrah, Dr Miranda Morris (on whose researches some of the Dhofari jewellery chapter is based), Salim Tabook of Exeter University, and Mrs Robin Butler. For additional photographs I would like to thank Sue Crawford (guns), Tom Foxall and Neil Potts.

I should also like to thank my husband, Donald, for reading the manuscript and for his many helpful comments.

Oman
and its neighbours

BAHRAIN

Strait of Hormuz

IRAN

Musandam

The Gulf

QATAR

Gulf of Oman

Buraimi

Sohar

Masna'ah

UNITED
ARAB
EMIRATES

The Batinah Coast

Barka
Matrah
Seeb ○MUSCAT

Dhahirah

Jebel Akhdar

Rostaq
Nizwa

Ibri
Jabrin
Bahla

Ibra
Sur

Sharqiya

Umm as Samim

Wahiba
Sands

SAUDI ARABIA

Masirah
Island

Haima

Jiddat al Harasis

Muqshin

Ras Duqm

Rub al-Khali

Dawqa

Arabian Sea

Ma'in

Dhofar

Thumrait

YEMEN

Habrut
Marbat
Halaaniyaat
Islands

Salalah
Raysut

(Huraidah)

N

(Ghaibun)

Ma'rib

Hadramaut

Mukalla

0 100 200

Kilometres

Aden

Introduction

OF all the traditional arts of Oman, the craft of the silversmith is perhaps the most beautiful and varied, as well as the best known outside the country. Oman has for centuries been renowned for the quality of its silverwork, and much of the silver jewellery found in other Gulf countries originated in Oman. (An interesting example of its dominance in this field is that in the early 1920s, when the country was still isolated and little known to outsiders, Dimple Haig whisky bottles were allegedly sent from as far up the Gulf as Kuwait to be covered with silver in Nizwa, long the centre of Oman's silver trade.) Such is the regard for Omani silverwork that many old, and indeed sometimes deliberately 'antiqued', pieces of silver available in the Gulf today are sold as Omani in order to enhance their value and reputation – though they may in fact be Yemeni, Saudi or Indian in origin, and it may take an experienced eye to discern this.

It is often difficult to be precise about the provenance of a particular piece. Given Oman's geographic position at the crossroads of ancient trade routes (both by land and sea) connecting India, the Far East, Africa and the Mediterranean lands, it is not surprising that pieces, as well as ideas, have crossed

borders and been assimilated into its traditions. However, within Oman there are certain traditional distinctions in design and use which may help to identify the place of origin be it Nizwa, Bahla, Ibri, Rostaq, the Batinah Coast, Sur, Salalah or the Sharqiyah (though these distinctions have become blurred as mobility has increased). It is also difficult to be precise about the names, and sometimes the specific uses, of various items of jewellery. These may vary from place to place, even to the extent that formerly a name used inside the old walls of Muscat might be unknown in Nizwa or elsewhere in the interior.

Chapter 1

General History

FOR thousands of years gold and silver have been worked in response to man's profound and universal need for personal adornment, which makes jewellery one of the oldest forms of decorative art. Apart from showing off his wealth and position through his own or his wife's jewellery, a husband could show his affection by giving handsome pieces. In addition, the wearing of certain pieces as amulets was seen as a means to ward off evil.

Gold jewellery has been discovered from the earliest known civilizations in Mesopotamia and Egypt, and silver was being worked in Asia Minor as early as the fourth millennium BC. By the early part of the third millennium BC silver was reaching Sumer in Mesopotamia from Elam in the east and from Anatolian silver mines at Keban on the Euphrates. It is possible that the ancient mines in the Binalud mountains west of Meshed and others near Isfahan produced silver, which could have been brought into Oman around this time: Sumerian and Old Babylonian tablets of four thousand and more years ago indicate that precious metals were used in trading transactions (particularly involving copper) between

Ur in Mesopotamia and the country known as Magan, which was almost certainly present-day Oman.

Artefacts found during recent excavations at Shisr in the Empty Quarter of the Arabian Peninsula, the earliest known inland centre for the incense trade, indicate commercial contacts with Mesopotamia and Syria as early as 3000 BC. There were well-established links between Mesopotamia and Umm an Nar (now Abu Dhabi) at around the same time. Traders from the civilizations north of the Gulf would have migrated south in search of a range of commodities, including myrrh and frankincense (which, being scarce, had a very high value). The Arabian peninsula thus formed a trading focus for spices, silk, ivory, gold, copper and gemstones – the last three all available in the Arabian hinterland. Land transport was facilitated by the domestication of the camel: carvings of camels on tombs at Umm an Nar and Buraimi, and the discovery of camel bones, indicate that the animal was by then known and eaten. It may have been used to transport copper from Arabian smelting sites to the ports, and it could well have been used to carry Arabian aromatics.

In addition, the navigational skills of Omani seafarers, which had been acknowledged since the third millennium BC, enabled trade to extend further afield – eastwards to China via India, and south and west to Egypt and Africa – supplementing the land routes to the Mediterranean. The recent discovery of carnelian beads etched with alkaline paste, a technique evolved in the Indus Valley, may well indicate a link between Oman and India in the second millennium BC. An anonymous Greek author and mariner, who left a written record for other mariners in *The Periplus of the Erythrean Sea* of the first century AD, mentions that the coast near Zanzibar was influenced by Arabia and refers to the Arab captains who sailed the route. Connections thus existed between the incense regions of Arabia and Africa, between the Hadramaut and Oman, and between these two and Mesopotamia, along the old incense routes. Pliny suggests a relationship going back to the fourteenth century BC, between the oldest known commercial empire in south Arabia, based at Ma'in, and the Minoans of Crete.

As a result of these links, Oman was subjected to influences from every corner of the known world and, being a main source of copper and incense, was

wealthy enough to benefit from them. Traders would doubtless have brought with them craftsmen who introduced to the area their own already highly developed techniques of metal-work. Arabia Felix, the cultivated part of the Arabian peninsula, kept its supremacy in wealth and trade until the Roman invasion in the first century BC.

However, the Arabs lost their seafaring monopoly as the navigational skills of Greek and Roman sailors increased, and they too learned how to use the monsoon winds. In addition, burials became simpler after the Roman Emperor Constantine declared Christianity the state religion in AD 323 , leading to reduced demand for exotic incenses and the decline of the frankincense market. Another cause of the area's decay was the collapse, through gradual silting up, of the Marib dam in Yemen, which was in ruins by the late AD sixth century . This led to a lessening of agriculture, as the vast network of complicated irrigation supported by the dam was ruined, and a consequent gradual decline in trade, which shifted to the Red Sea route. There followed a long period of relative isolation, though Omani sailors continued to head east towards China and south-west to East

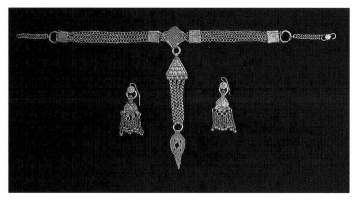

▲ *Silver loop-in-loop chain and decoration, used for securing a headdress, and ear-rings with danglers. The separate strands of chain are held together by bands of silver (See page 65)*

Africa, where Oman established an empire, based on Zanzibar.

With the advent of Islam in the seventh century, the Arabs took over the main sources of precious metals that the Byzantine and Sassanian empires had exploited – in Ethiopia, Nubia, Persia, Central Asia and the Caucasus – but the subsequent period of decline in much of Arabia inhibited what had been the highly developed craft of metal-working. Their craftsmen being inferior, they hired Egyptian, Jewish,

Syrian and Persian metal-workers, who were willing to travel and set up schools of art. Moreover, in early Islamic times the craftsman was thought not to contribute directly to the livelihood of the tribe, and his work was less valued; as a result, metal-working became the sphere of non-Muslims. Subsequently, however, standards improved, guilds were set up, and smithing became an acceptable (and Muslim) craft.

The bedu did not indulge in artisan work, so they commissioned silversmiths (mainly townspeople from the settled areas) to work on demand, usually on an individual basis. The smiths would vary the quality of both the work and the metal to suit the taste and budget of the purchaser. When increasing affluence made gold more popular many silversmiths had trouble working a different metal, and goldwork tended to become concentrated in the larger population centres. In the process it became less individual and lost much of its originality of design, and the concept of a craftsman using his skills and ideas for a particular customer's needs and tastes largely disappeared.

However, a preference for silverwork endured in much of the hinterland across the region; ancient styles and techniques were preserved, and a respect for tradition, both in acquiring and wearing jewellery was maintained. This explains why, for example, chains, links, styles of headpiece and the ornament of complicated ear-rings found in bedu silver are so similar to jewellery worn by Moroccan mountain women; why pendants and bracelets resemble those worn by the Turkomans; and why wrought silver anklets resemble those of the Bakhtiar, Qashq'ai and other tribes of Iran. An interesting example of respect for tradition occurred in the early 1970s, when the maker of a bedu bracelet was asked to add an extra band to a bracelet, which would have changed the style a little: he not only refused but positively objected to the request.

Islam discouraged the wearing of gold and precious stones by men, and silver was traditionally more acceptable for both men and women; this had the advantage that, because it was a less costly metal, bigger and more impressive pieces could be made. It was not unknown in parts of the interior for a man to wear a gold ear-ring – perhaps following a belief, originating in India, that wearing a pendant in the left

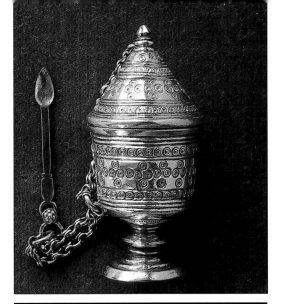

◀ *Lidded silver pot with ornate embossing and a shallow spoon attached by a chain – probably for mixing and dispensing kohl.*

◀ *Tweezers and two silver thorn-picks with chain and silver case, from Ibri.*

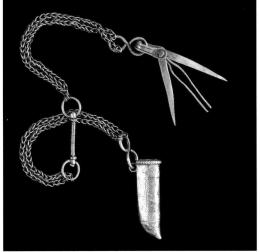

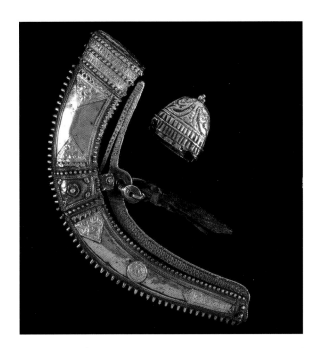

▲ *Silver* talahiq *(powder horn) from the Sur area, decorated with embossed gold, soldered on; the design of the top is typical of the Sharqiyah. Gunpowder, put in from the top is released at the bottom when the lever on the side of the main body is pulled. The* talahiq *was worn at the back of the neck on a strap (to keep the powder dry when swimming, it is said).*

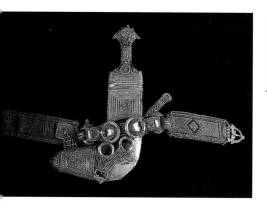

◀ *A Saidi* khanjar, *traditionally worn by the Al bu Said family. The shape of the pommel differs from the more usual, almost flat-topped form of other* khanjars.

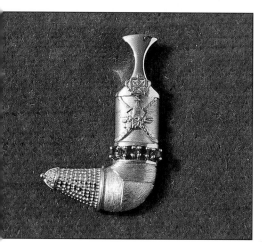

◀ *A small, exquisite example of modern 'patriotic' jewellery. A brooch in the form of a silver* khanjar, *decorated with the Omani crest in gold, with rubies and emeralds.*

ear would aid weak sight. (Interestingly, a 1995 excavation of an AD seventh-century-Alanic catacomb in the North Caucasus, in the district of Stavropol, uncovered a man with a gold ring in his left ear.) Male accoutrements, such as silver buckles, powder-horns and thorn-picks, were sometimes decorated with gold, and sometimes a simple *khanjar* (the curved dagger worn so extensively in Oman) might be ornamented with gold thread; however, the traditional *khanjar* of the Omani Royal Family remains entirely of silver. Modern *khanjars* are now sometimes made of gold (usually overseas rather than in Oman), and gold is the norm for women's jewellery ; a woman would trade up from silver jewellery to gold, as and when she could afford it. These days only the older generation wear silver.

A little silver is still worked in Nizwa, Bahla, Ibri, the Sharqiyah and Matrah, perhaps with an Indian working alongside the Omani. Much of the silver now sold in the souks is machine-made in India and no longer Omani work. With the current interest in local craft, the tradition of passing skills from father to son is ready for revival. Some villages boast an elderly silversmith ready to pass on the art to the next generation.

Chapter 2

EARLY INFLUENCES

EARLY contact with the outside world is still reflected in current designs, styles and techniques of Omani jewellery. The techniques of chasing, engraving, piercing, filigree and granulation were all known as early as the third millennium BC. Filigree, repoussé and granulation were used in making the royal jewellery of Ur, and with a skill that suggests that, in Mesopotamia at least, these techniques were not new; a dagger and sheath of around 2600 BC from Ur (in the Baghdad Museum, Iraq) is a fine example of this early work.

The Egyptologist, Margaret Murray, maintains that in no country, ancient or modern (except possibly Renaissance Italy), did jewellers ever match the beauty of design or the delicacy of craftsmanship achieved in ancient Egypt. The first examples to show this skill were gold bracelets of the Proto-Dynastic period from the tomb of King Zer, dating to 3500 BC at the latest but possibly much earlier, and gold in the form of gold-leaf was used to ornament silver jewellery found in tombs of around 2500 BC.

The next great period for goldwork was the Twelfth Dynasty, around 2000 BC, when the characteristic jewellery was made of small, flat pieces

of gold mixed with spirals of gold wire to form a
design. Granulation was a prominent feature and
seems to have been introduced to Egypt during this
period. By the time of Tutankhamun (r. 1333–1323 BC)
the jeweller's repertoire included inlaying, chasing,
repoussé work, embossing, filigree work in twisted
gold-wire and granulation. Tutankhamun's tomb
jewellery shows not only the extensive use of pendant
ornaments and beads, particularly turquoise and
carnelian, but also the use of scarlet-tinted gold – once
again in vogue in Oman in the 1970s.

It is known from wall inscriptions that metal was
smelted in the Nile valley by the Fifth Dynasty (i.e.
before 2300 BC). The gold used occurred in the
alluvium from wadi-beds and in veins of white
quartz present in the igneous rocks of the hills
between the Nile and the Red Sea. The ore was
melted in a crucible over a fire kept at a fierce heat
by men with blowpipes of reed tipped with clay – a
process depicted in wall paintings of around 2000 BC
in tombs at Beni Hassan. The molten metal was
cooled, beaten out into sheets of the required
thickness with smooth stones, and then cut into
shape.

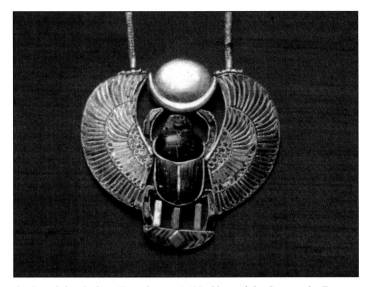

▲ *Scarab beetle from Tutankamun's 'Necklace of the Sun on the Eastern
Horizon'; gold, lapis lazuli and carnelian. (See page 24)*

The Egyptians probably managed to refine pure
silver before 2000 BC, but, on account of its rarity, it
does not seem to have been much used until the
Eighteenth Dynasty (1550–1307 BC), when it was used
mainly for dishes and bowls rather than jewellery.
However, Queen Hetepheres, mother of Cheops
(r. 2551–2528 BC), had silver bangles inlaid with

turquoise, lapis lazuli and carnelian, and there are simple silver bangles dating to this period in the British Museum.

Silver also featured in the Oxus Treasure (600–300 BC) and was used for amulets. A silver pendant of the second or third century AD inscribed to a moon god was found at Ma'in in Yemen, and by the fourth century AD, during the Byzantine period, silver was being used more extensively. Silver necklaces, bangles and bracelets, some very similar to the simplest of those still produced in Oman, were found in the Nubian tombs of Ballana and Qustal. In the ninth century AD silver was favoured by Queen Bilkis of Yemen for her jewellery.

Egyptian and Mesopotamian metal-work influenced other civilizations directly or indirectly. In Crete, Minoan jewellery from about 1700 BC shows that filigree, granulation and repoussé techniques had been well mastered; a particularly fine example is the famous golden bee pendant from Khrysolakhos near Mallia. Gold jewellery from seventh- and sixth-century BC Tharros in Sardinia (which was then probably an early Phoenician trading post) and Etruscan jewellery of the fourth

century BC used granulation; the Greeks also used filigree work and pendant bells. Graham Hughes suggests that the Etruscans may have used immigrant Greek craftsmen, whose skill in such techniques as granulation may have been inherited from the Phoenicians, who were famous for their goldwork. The Phoenicians also made necklaces with pendants at regular intervals and used colourful beads. Earrings from Byzantium included the crescent shape – symbol of the Moon God – on a wire ring. The Romans perfected the technique of wire-making and wore many large rings. And twisted metal-work, such as features in some Dhofari bracelets, was used by the Celts, whose ideas may have been brought to Arabia by Phoenician seafarers in the first century BC.

Despite some early use of silver, nearly all surviving jewellery – Mesopotamian, Egyptian, Phoenician, Greek, Etruscan and Roman – is made of gold. This is partly because silver was so rare (it takes pride of place before gold in ancient lists of Egypt's Middle Kingdom c. 2040–1640 BC), and partly because it is a much less durable metal than gold. Another reason is that the Christians and barbarians melted down vast quantities

of silverwork around the fourth century AD, when sources of the metal became depleted.

The Sassanians, whose empire stretched from the Mediterranean to India between the third and seventh centuries AD, excelled in metal-work. They exerted a great influence on early Islamic art. Expanding trade extended Sassanian influence eastwards as far as China, but, as trade continued to grow, Chinese influence began to be felt in the reverse direction, affecting Persian and Islamic art. New ideas, perhaps notably in the use of stones, flowed westwards along the Silk Road that linked the Gulf with China, Tibet, Nepal and Bhutan, and perhaps via the important Omani seafaring links with the Far East and East Africa that existed at least from the eighth century. During the Tang era in China (AD 618–907) silverwork with elaborate head-dresses and hair ornaments, ear-rings, rings, bracelets and pendants may well have been influenced by both Persia and India. During the Yuan Dynasty, under Kublai Khan in the 1270s, heavy, intricately worked silver jewellery was often inlaid with coral and turquoise. In the nineteenth century the use of little silver boxes was common

not only to Oman and Yemen but also to China.

Indian influence in Oman has always been strong, and jewellery from the west coast of India must have been brought back by Arab traders over many centuries. The similarities in style between bedu jewellery and that of Gujarat, Marwar, Kattiawar, Kutch, Sind and Baluchistan is noticeable, especially in the use of bells and the inclusion of rattling objects inside hollow metal. The bell shape was a feature of earlier jewellery, for example in gold pendants from the Oxus Treasure and in jewellery of the Achaemenid period (550–330 BC) excavated at the fourth-century BC site of the ancient Persian city of Pasargadae. The motifs of Indian folk jewellery were often Muslim and Persian, with leaves and the tree of life prominent among them: Parsee jewellery as recently as the 1880s was still in the traditional style of Sassanian Persia, and it was noted for its fine workmanship in both gold and silver – though the work was probably done by Hindu jewellers. The Persians mixed freely with the peoples of the Gulf from pre-Islamic times, so similarities in jewellery from the two sides of the Gulf are to be expected.

The trade routes to East Africa and, after the

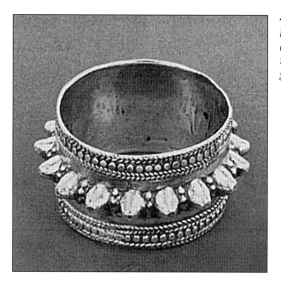

◄ *This type of bracelet is worn all over Oman, now often in gold.*

▶ *A typical bracelet from Sur, with a double row of bosses and a hinged opening (See page 59.)*

advent of Islam, the movement of pilgrims from places as distant as Nigeria brought in ideas from the west; there is a distinct resemblance between some of the chunky anklets of Arabia and Ashanti work, and the coiled snake-headed bracelets are similar too. Just as Persian carpets were sold en route to Mecca to pay the expenses of the *Hajj*, or Islamic pilgrimage, so jewellery (in particular, beads) was used as a form of barter. Styles thus introduced into the Middle East

were retained and copied. It has been suggested, for example, that the toe-ring is of African origin. Possibly because the cowrie shell was once used as a form of currency in West Africa, its shape occurs in gold and silver Omani beads – though indeed the shell is also common to the waters of Oman.

It is virtually impossible to trace the precise origins and inspirations of traditional jewellery. Many of the designs and techniques occur all over the Middle

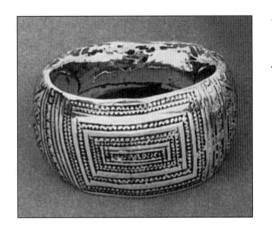

◄ A bracelet from Ibri; the back is rounded but the front is wider and slightly flattened.

Pakistanis do today; some of the gold and silver rings from Sur in Oman, with a decoration rather like a dome-shaped cage (illustrated below), are very similar to Jewish wedding-rings. It would seem, therefore, that good ideas were quickly disseminated.

East, India and beyond, and they have common ancestry in the earliest civilizations. Jewellery was traditionally a craft of patronage. The royal or wealthy traveller often took his jeweller round with him. Moreover, an inter-regional network of ethnic minorities practised the craft of jewellery. Many Yemeni Jews set up businesses in Palestine and Jordan, and the best silverwork in Yemen and particularly in Iraq was made by Jews. Jews may also have worked silver in the Gulf, as Indians and

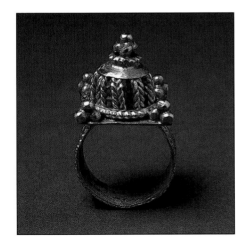

▲ Silver Zar *ring.*

Chapter 3

PURPOSES OF JEWELLERY

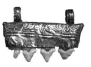

Amuletic

From early times man seems to have recognised the intrinsic allure of gold and silver and fashioned them to adorn himself. Gold and silver represented wealth and power, becoming an attribute of governance. The smelting and crafting gathered a religious significance and the status of goldsmiths and silversmiths thus became enhanced. To protect himself against evil, the man turned to amulets of gold and silver. For the Ancients, gold was associated with the sun, and silver with the moon, long credited with protecting against the Evil Eye. Mesopotamian jewellery with little carved pendants of animals and objects, dated about 5000 BC, was probably worn for amuletic purposes as well as for decoration.

At around the same time the cowrie, or cowrie-shaped bead, was regarded as a fertility symbol and worn by pregnant women. The snake was attributed magical powers by the Egyptians, and by the Dilmun culture of Bahrain (where in the early second millennium BC people often had snake amulets buried with them, or beneath their houses, often accompanied by a pearl or blue bead). Amuletic figures in ivory, carnelian and amethyst

were used in Egypt during the Sixth Dynasty (2323–2150 BC). Some represented particular gods, imparting the powers of these gods. Amulets in the form of parts of the body protected those parts. The use of anthropomorphic objects was a feature of Ganges culture between 1700 and 1000 BC. Amulets were worn by the Assyrians of the ninth century BC. A hand seems to have symbolised protection against the Evil Eye, a fish represented fertility, and a bird love.

The most important amulet to the ancient Egyptians was the scarab (illustrated on page 18). Made in stone or glazed ware, it was either worn or formed part of funerary equipment. Scarabs have been found buried with the Pharaohs, amongst their other jewellery. The amulet was either hung round the neck or concealed in bandages over the heart to ensure that the heart of the man did not give evidence against him when weighed in the balance before the all-powerful Osiris. It seems to have been sacred in Egypt since prehistoric times, appearing as early as the First Dynasty, in the early third millennium BC, and only disappearing under the Ptolemies (304–30 BC). It occurs in the image of the dung beetle

(*scarabeus sacer*), a creature that lays its eggs in the droppings of animals and rolls the dung into a ball which it pushes along with its hind legs. Since this was seen as symbolising the sun crossing the heavens propelled by an unseen power, unseen power came to be represented as a beetle. The scarab beetle may also lay its eggs in the dead body of another beetle. As a result, the ancient Egyptians took it as an emblem of reincarnation – a further demonstration of the life-giving attributes of the sun. Scarabs were also made by the Hyksos in Palestine, long before they invaded Egypt in the middle of the first millennium BC, and have been found in tombs at Jericho. They were used by the Etruscans as a sacred symbol in the ninth century BC, and in the sixth century BC the Greek trading colony of Naukratis in the Nile delta had a regular trade in scarabs for export to the Aegean.

Although representation of the human form is generally forbidden by Islam, the pre-Islamic tradition survived until recently in the making of a variety of forms resembling little silver figures, often hung on chains. They were regarded as a fertility symbol and were said in Oman to be made only by women, who wore them during pregnancy to aid them in

childbirth. They may have been worn by children to help them walk.

The human form is also represented on the back of silver medallions, where a small figure of a *djinn* is sometimes etched to avert evil (he may have his feet shackled to prevent him harming the wearer). Bedu jewellery also includes old glass bottle-stoppers, dried seed pods and pieces of wood, horn, bone or glass, set in silver and hung on elaborate necklaces. While mostly worn primarily to ward off illness and to protect the wearer, some of these may also have

served the more practical purpose of providing teething objects for babies. Also set in silver for wearing on a chain are such things as foxes' teeth: these must surely be amuletic and not simply trophies of the hunt. (Pendant amulets containing teeth are neither new nor purely local; examples have been found in Anglo-Saxon graves of the seventh century AD.) Bells on anklets and bracelets, or pebbles rattling in metal hollows, scare off evil spirits. Such a sound made by anklets is alluded to in the Bible (Isaiah 3:16; where the daughters of Zion are said to have made a

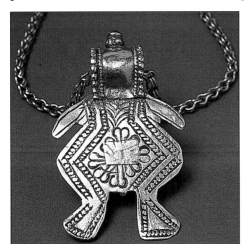

◀ *Small silver amuletic figure, said to have been made in Adam, south of Nizwa.*

▶ *Amulets from the interior. Three small silver figures, and a silver necklace festooned with talismans (a figure and pieces of slate, wood and polished green stone). The centrepiece of the necklace is a small silver bowl with turquoise set in the middle, apparently for mixing kohl. (On Kurdish necklaces of this type, the bowl is called a begging bowl, and the piece is worn by children.)*

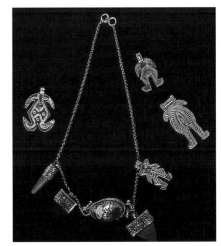

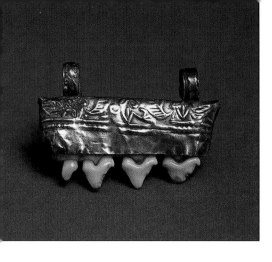

◀ *An amulet of fox jawbone set in silver to be worn on a chain.*

▶ *Round anklet with jingling bells, probably from the Batinah.*

▼ *Hollow, embossed silver Batinah bracelet with small stones inside to rattle with the wearer's movements; probably worn on the upper arm.*

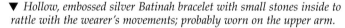

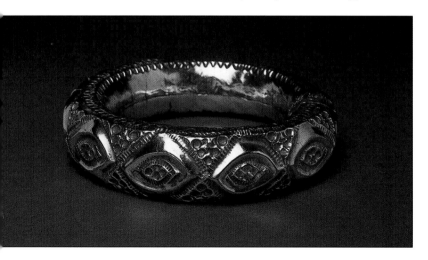

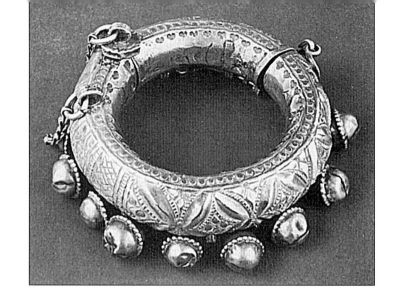

tinkling with their feet). Ancient Greeks wore them in the seventh century BC, and they are still part of present-day tradition in Afghanistan, as in Oman.

In general, amulets are worn by women and children much more than by men: their resistance to evil is considered to be weaker. Some of the simpler pendants are worn by children of four or five, until they go to school. Wendell Phillips has reported young children being kept deliberately unkempt, especially in public, so as to distract the dreaded Evil Eye, which was more likely to be attracted to the healthy and happy. The most common form of amulet for children was a verse of the Koran in a small silver

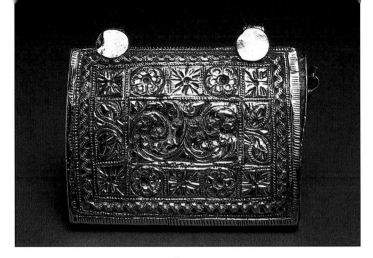

▲ *Embossed, side-opening silver* hirz *from Nizwa. It contained when purchased not verses from the Koran but pieces of cardboard to help keep its shape.*

box (*hirz*) worn around the neck. Mercury was deemed to have properties similar to silver. In some places in the interior of Oman, at least as recently as the 1970s, it was carried in silver containers to be taken orally in small quantities or rubbed into the gums of babies to protect them against evil influences.

Beads of particular shapes and colours are thought to give protection against some illnesses and to aid women in childbirth and lactation. For example, in some parts of Arabia there are specific beads that guard against liver ailments and jaundice; a lustrous brown stone is thought to ward off headaches; and a bead called *hulug* is worn against the throat as a cure for tonsillitis. A cluster containing cream and white beads, called *sumluk* ('we shall possess all'), enhance the wearer's hold over a potentially straying husband. Polished, heart-shaped love beads may be worn. Dark green cube beads aid conception and keep away evil forces after delivery. Green stones, though rare in northern Oman, are found in Dhofari jewellery and are reckoned in some areas to cure post-natal infection. White stones – more common in Syria and Jordan – are said to promote lactation, while blue beads (including the widely used turquoise) protect against evil and the malignant forces of the envious; red stones, so common in modern jewellery, are said to promote health, and specifically to prevent eye disease and alleviate inflammation and bleeding. Freya Stark mentions seeing in South Yemen a carnelian set in silver, worn around the neck on a black cord, being used to stop bleeding from a wound. A common talismanic inscription is '*Ma'sha Allah*' ('as God willed').

Social

Jewellery is also worn for the social prestige it brings, its implication of a man's wealth and a woman's

married status. Good pieces represent an investment for the owner and a form of security in time of war. Uniquely among the decorative arts, jewellery can also serve as a form of currency; to many bedu families it constitutes the bank account. It may also demonstrate appreciation of craftsmanship, in contrast to a total lack of discernment.

A woman can wear her jewellery with pride because of its associations with money, power, religion and love. As an investment for her future, it has long been hers by law, in Oman and Greater Arabia, to do with as she alone wishes. It has formed some sort of security against hard times and possible divorce. Needing to feel some degree of independence in a culture where a man may have up to four wives and divorce is easy, women kept and keep a separate account of their possessions, including jewellery. This is usually given by the husband to his wife on marriage as part of the bride-price, or bought by the bride's father out of the bride-price. Specific pieces of negotiable value, formerly in silver but now in gold, are often included in the dowry.

Amongst the bedu a wedding ring as such is not necessary: in the Sharqiyah an amulet (*zand*) may be

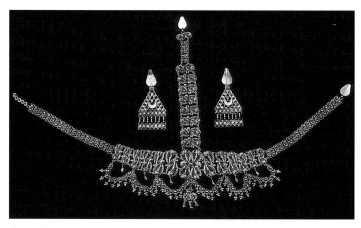

▲ *Gold head decoration and earings. The main portion hangs across the forehead.*

worn on each arm by married women; and in urban areas a Western style gold band is now the norm. The Prophet urged Muslims to offer rings to their brides, so a set of rings is often included in the dowry. It might take the form of one ring for each finger and thumb of each hand: a piece called *qaf* ('glove'), often thought of as 'Indian', appears in some tribal jewellery in the Gulf and incorporates chainwork that links the five rings together, forming a decorative piece that covers the back of the hand down to the

wrist, where it culminates in a bracelet. Teheran Museum has a fine example of a *qaf* using four-way loop-in-loop chains across the back of the head, from Ziwiyeh, northern Iran, *c.* ninth or eighth century BC.

The main pieces worn by a bride at her wedding would include a headpiece called *mafraq*, bracelets called *banajari*, a necklace of gold coins called *kalada* or *marriya shnaf* and ear-rings called *durrur*. Often a bride

▼ *Gold necklace of chainwork and gold coins* (marra). *It is accompanied by matching earrings and a finger-ring embellished with turquoise.*

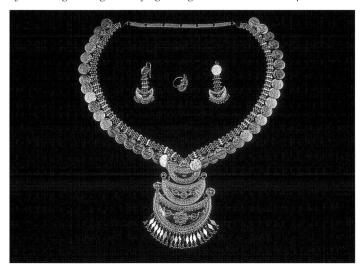

would remember her wedding day by the sheer weight of metal she carried as much as anything else. The important thing was to wear as much jewellery as possible, whether owned or borrowed (Islam discourages the hoarding of precious objects, so the ability to lend jewellery to others may have helped to ease the owner's guilt for possessing it). For wedding dances Baluch women might wear a special silver horse-shaped anklet, thicker in the middle than near the opening, called *padink*. In addition to jewellery a bride would also be adorned with henna on hands and feet.

Certain pieces may be much cherished and are not sold in any circumstances short of death – the proceeds of an Iraqi woman's nose-ring, for example, traditionally have paid for her shroud. Since jewellery was so often commissioned specially for a particular person (perhaps by her husband) or given as part of the dowry, there is a tradition that it should have only one owner, and it is considered unacceptable to a new wife to wear the jewellery of a wife who has died. Although some pieces are inherited, many are melted down on the death of their owners, either for the metal value or to be worked into new pieces. As a

result, it is rare to find complete pieces of bedu jewellery more than fifty years old (much old jewellery was melted down for bullion, particularly when the price of silver went very high in 1973 and 1974). Some jewellery might be given at special times, such as a birth, wedding or circumcision, but for the most part there do not seem to have been many specific pieces for specific occasions.

At birth a likely gift is a talisman and perhaps anklets; at circumcision a necklace consisting of a big medallion (*sumt*) on a chain with Maria Theresa thaler may be given to the boy's mother; for a wedding hair ornaments are often given, especially in Dhofar.

Many of these customs are dying out and some pieces of jewellery described are no longer in common usage, but none is extinct.

The older generation still wear what they have whilst the young are likely to wear gold, sometimes copying traditional pieces.

Chapter 4

MATERIALS

Metals

Man discovered early on that gold and silver were the only two metals that did not discolour the skin when worn. This made them ideal for jewellery (though brass was sometimes used by poorer people, and the early Egyptians also used electrum, a naturally occurring compound of gold and silver). The metal was embellished with precious and semi-precious stones, glass and pottery to make pieces of jewellery, and it also often featured in garments which were elaborately embroidered with gold and silver thread and further ornamented with applied coins and metal shapes.

Gold, thought to have been first extracted from alluvial deposits in the sixth millennium BC, is considered the perfect medium for jewellery. It is very stable and, being durable yet malleable, can be worked into the finest wire and thinnest sheet. Both the gold and the silver used in Oman may originally have come from the Arabian interior, where mines in the Mahd Adh Dhabab district and at Samrah were in operation about a thousand years ago. Gold occurred fairly widely in the Middle East, from Egypt to Asia Minor (where the golden sands of the River Pactolus

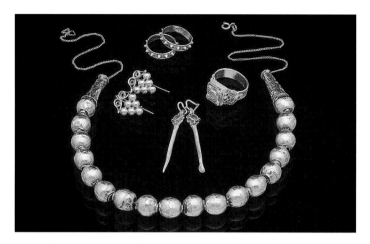

◀ *Gold ornaments:*

Top: *Pair of small bossed rings.*
Centre left: *Pair of ear-ings with the mulberry design.*
Centre: *A small ear-cleaner and toothpick, suitable for wearing on a chain.*
Centre right: *One of a pair of Zar rings, decorated but with no stone.*
Bottom: *Batinah beads of thin gold on a wax base.*

▶ *Intricate gold necklace with a cylindrial centrepiece, such as is often used for a* hirz.

were the source of the riches of the Lydian king Croesus). Today most of the gold and silver used in Oman is imported in bar form.

There have been fairly recent reports of traces of silver in the mountains of Oman, but the chief source for locally made jewellery and artefacts the past two centuries has been coins. Amongst coins melted for their metal content (or used intact for their decorative effect, particularly in necklaces) are the Maria Theresa thaler, the Indian rupee, the Turkish *majeedi* and the British sovereign. The Maria Theresa thaler, in particular, because of its high and

consistent silver content, provided metal of excellent quality. Customers and brides tend to prefer their jewellery to be modern and in good condition. Melting down was common until demand from collectors and museums led to good prices. Old silverwork is usually of higher quality metal, and this, too, has led to high prices in the souks.

The silver is melted in a crucible over a charcoal hearth – kept glowing by bellows (the ancient Egyptians had long blowpipes for this) – and then rolled into sheets or rods which are subsequently cut

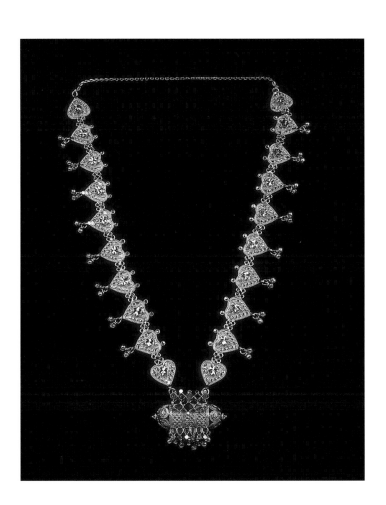

and shaped over a brazier. A high silver content gives objects a better sheen but, because the metal is relatively soft, patterns in pure silver tend to wear away, so a proportion of copper is often alloyed with the silver to give durability, and zinc and tin may be added to reduce the melting point (particularly for solders). It used to be said that the silver used for working in the interior of Oman appeared to be of the same quality as the Maria Theresa thaler, whilst in coastal areas items of lower-grade silver were found. An exception was Sur, where good-quality metal was normally used. Clearly some coastal silverwork has always been imported, largely from Baluchistan or India. Some of this looks and feels thin and tinny, but not all thin silver is poor quality metal. Hallmarking is rare in Oman, as so much of the silver was specially commissioned, but many (particularly Yemeni) silversmiths stamped their work with their own individual mark.

Traditionally, gold was used to ornament silver jewellery, particularly in Sur and the Sharqiyah, and gold wash was also used. Gold-leaf was formed by hammering the metal between paper sheets made from the fibrous bast of the mulberry tree (a process

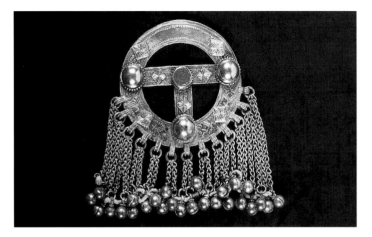

▲ *Hair decoration from the interior adorned with squares of gold-leaf and a red plastic seal in the centre; such pieces are worn low at the back of the head, particularly in the Bahla and Jabrin areas, and are similar to jewellery worn by Turkoman women.*

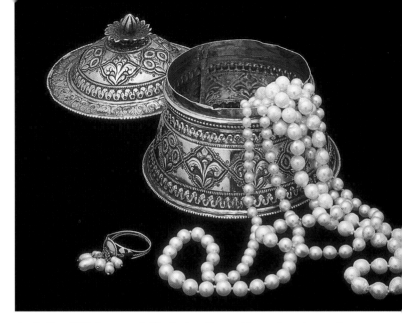

▲ *A silver lidded pot, probably for jewellery, with pearls and a pearl-and-gold ring from Bahrain.*

used by the Persians, and, until the beginning of this century, in London) and then applied over the silver. Sheet gold, on the other hand, was soldered or sweated onto the silver base, decorative effects being produced by cutting away parts of the gold overlay to allow the silver to show through. Sometimes gold coins were simply hammered on to the silver base, as illustrated on page 49. Today an increasing amount of

imported European jewellery is available in Oman, using precious stones (particularly emeralds and rubies, the colours of the Omani flag). There is also 'patriotic' jewellery – in the form of gold pendants, brooches and ear-rings using the Omani emblem of *khanjar* and crossed swords – aimed mainly at the visitor and made largely overseas.(Illustrated on page 16.)

Before 1970 it was only the Royal Family and the

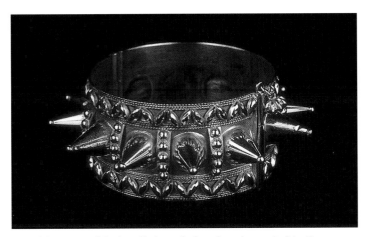

▲ *Gold version of the heavily bossed silver bracelet typical in Oman; one is worn on each wrist.*

families of rich merchants that would have been able to afford solid gold jewellery. Much of the metal was imported from India through people like the Khojah merchants of Matrah. The American Consul in Muscat in 1907 described visiting a wealthy Muscati lady whose jewellery was mostly gold. It included a few dozen heavy gold bracelets, bands of gold with bosses; necklets of gold bands about four inches in diameter; gold boxes for Koranic inscriptions on beautiful, long gold chains; and thick collars of gold chains. He also noted flexible silver belts, rings of turquoise and lapis lazuli with heavy gold settings and a profusion of silver ornaments both for wear and for household use.

Today much of the goldwork available in the souks of northern Oman is made in India. It is bought by people who formerly could only have afforded silver, and who often sell their old silver jewellery in exchange. The goldwork and silverwork made in Oman to order are mostly traditional in style. Old gold jewellery is now virtually impossible to find, since gold was so valuable that any old or unwanted pieces were taken to the souk to be melted down and made up into a new style. For example, a bracelet with plain bosses was once common in silver and was repeated in gold (often tinted red in the 1970s). Now the fashion in Oman has changed; red gold is no longer in vogue, and the once plain protrusions are embellished with a decoration of gold thread and a granule on the end (though the simpler form is still found elsewhere in the Gulf).

Nowadays some eighty per cent of the metalsmiths in and around Muscat are from the Indian subcontinent, predominantly from Pakistan.

In the Matrah souk, where gold refining is still done, the smith works over charcoal with electric bellows, melting together 12 grams of mixed-quality gold and 24 grams of silver dust. He then pours the molten liquid into cold water before reheating it, with nitric acid and other chemicals, and inserts copper rods to draw the silver from the liquid. The remaining dust is gold residue, which, when remelted, is formed into bars of pure 24-carat gold.

Stones

Not surprisingly, traditional jewellery tends to concentrate on materials available locally. In the areas bordering the Gulf this means pearls, which have influenced the way of life and the entire economy of the area for centuries. In the interior of Oman, however, the lifestyle was for the most part rugged, and jewellery was of the simplest. If available, blue stone was used, on account of its reputation for averting evil (its popularity was also perhaps connected with the fact that the sapphire is seen as symbolising that much-prized virtue, chastity). Particularly favoured was turquoise (*pierre turquoise*, or Turkish stone, so called because in historical times

it came from Turkestan, via the Turkish dominions), which has the reputation of glowing when the wearer is content and turning dull if the wearer is sad. Fashioned into amulets, scarabs and beads by the Egyptians, who mined it in the Sinai Peninsula in the fourth millennium BC, it has remained popular ever since. Most of the turquoise now worn by the bedu comes from Saudi Arabia and the Yemen, and is streaked as a result of the matrix in which it occurs.

Blue and red are the traditional colours for jewellery stones, but green is increasingly popular. The most frequently used red stones are garnet, carnelian, amber and coral. Glass (which can be made to look more precious than it is by careful cutting) is also used. Garnet, much favoured by the Romans (its name stems from the resemblance of its colour to pomegranate pulp), may well have come from the

◀ *A ring for the little finger, with a large turquoise stone.*

▶ *A pair of rings for index fingers, also with turquoise stones.*

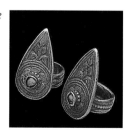

gravel beds of the Arabian Peninsula. Carnelian (or cornelian) is a quartz of a glowing red colour – easily imitated in glass – or a reddish brown or even orange. Much of it is mined in the Sinai Peninsula, it seems to have been favoured by Roman engravers, and it has been popular in bead form through the ages. The author of *The Periplus of the Erythrean Sea*, writing in the first century, mentions the carnelian trade from the Indus Valley. It was used as long ago as around 4000 BC by the pre-dynastic Badrians of Upper Egypt.

Amber – the word comes from the Arabic *anbar* – has been treasured and used in jewellery for thousands of years (an early amber-bead necklace, found in Flintshire in Wales, dates to about 1400 BC). It is the resin of pine trees (sometimes with minute insects trapped inside) that has been fossilised, but not petrified, by pressure from soil, ice or water. It is solid and durable but light enough to float in salt water and soft enough to work. The Romans ground it up for use as a healing agent; the Greeks prized its magnetic qualities when rubbed, and it became extremely popular, and expensive, in medieval Europe, perhaps due to the legends attached to it, such as that it was the petrified tears of God. Heather

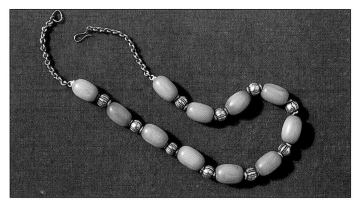

▲ *A Yemeni necklace of amber and silver beads.*

Colyer Ross reports an Arab legend to the effect that it is the solidified urine of the lynx, the male producing a darker colour than the female.

Coral (*murjan* in Arabic) comes in colours ranging widely, including from black and white. Dark pink or red are most favoured for jewellery. It is formed from the coral secretions of minute sea animals. Most of that used in Oman probably comes from the Red Sea, though that from the coast of North Africa is considered finer. Dark coral comes from waters deeper than 20 metres. For centuries coral has been

used for amulets and talismans, and jewellery has used the interesting shapes and decorative effects that its branches can produce, as well as incorporating beads made from its base. Coral was probably traded for frankincense between Dhofar and the Red Sea. The fact that it is used quite extensively in the interior of Oman is a further indication of its use in trade. Coral seems always to have been associated with wisdom. The Chinese ascribed magical qualities to it. Greek myth has it that coral was the blood that dripped from Medusa's severed head.

Agate is a crypto-crystalline sub-species of quartz, much used by the Tang Dynasty of seventh – and eighth-century China. Agate beads have always been popular with the bedu. Semi-pellucid, with its colours arranged in stripes or bands, or blended in clouds, agate is often dyed by jewellers to enhance the patterns. Glazed compounds, faience and coloured glass are also all used in jewellery. The Egyptians first used coloured glass to imitate gemstones, and by the New Kingdom (c. 1550–1070 BC) they were using it to imitate lapis lazuli, turquoise, carnelian and feldspar.

Beads of all sorts have been used in jewellery since time immemorial. They have been gold, silver, or precious or semi-precious stones, but they have also been made from drilled bone, seeds, wood, ivory, shell or even teeth – which provided beads cheap enough to be incorporated in any piece. Some of the finest examples from the ancient world can be found in the British Museum. Outstanding are the shell, carnelian, agate and steatite beads of the Badarians. Other examples dating from the middle Bronze Age include Kingdom (c. 2040–1640 BC) strings of beads; necklaces from the pan graves of Mostegadda in Middle Egypt (c. 1580 BC); others from Jericho, and a thirteenth century tomb at Tel es Saideyeh in Jordan; Achaemenian necklaces from Pasargadae in the fourth century BC; Parthian necklaces from the first century in Iran; and beads from a tomb (c. 100 AD) at Jawan in Saudi Arabia.

Beads, in their various shapes, sizes and materials, were carried extensively on the great trade routes for use in barter and as currency. If of gold or silver, the large ones are generally made in two pieces, embossed, decorated and soldered together. Even small beads are seldom solid – to lower their weight and value – and are likely to be made from sheet metal folded to form the desired shape.

Chapter 5

TECHNIQUES

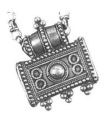

GOLD and silver are usually **alloyed** with each other, for greater durability or with other metals. They also become less malleable when continually hammered. Malleability is restored by **annealing.** This involves heating the metal to 700° C then gradually cooling it – on stone rather than in water, which tends to make it brittle. It can then be worked into the shape desired by a variety of other techniques.

Most goldware and silverwork throughout the Middle East is hollow and made of sheet metal beaten into dies shaped to form the two halves of the intended piece. These are then soldered together, using borax as a flux to coat the metal and so prevent oxidation (a skin of oxide inhibits the flow and adhesion of the solder). Another method of joining two pieces of metal is **fusing,** or melting them together under intense heat and using copper carbonate as a flux – a technique requiring great skill. Fusing is used in fine filigree work and in applying to a flat surface the tiny balls of **granulation.** (See page 42.)

Before soldering or fusing, the components are fashioned by casting or by various techniques involving hammering sheet metal. Small geometric shapes are often cut from the sheet metal or beaten

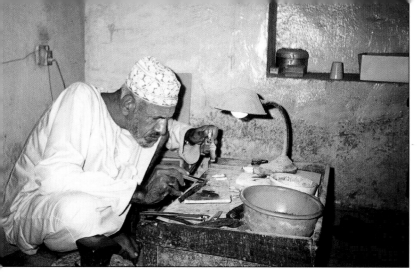

▲ *Silversmith at work in the Matrah souk.*

from small spheres which, soldered and fused to larger pieces, produce interesting decoration.

Casting is usually done by making a model which is impressed into a two-part sand mould. The mould is then opened to remove the model, the two parts are reassembled, and molten metal is poured through a small hole into the cavity left by the model. After cooling, the mould is again opened to retrieve the cast. The Egyptians perfected the technique of casting using wax. For solid casting, a solid beeswax model was coated with clay and heated, so that the clay hardened, and the wax melted and ran out through holes left for that purpose. Through these holes the molten metal was introduced. After it had cooled, the clay was broken away to reveal the cast. For the lost-wax, or *cire-perdue*, method of hollow casting, a quartz-sand model was made, which was thinly coated with beeswax before being covered in clay in the same way as for solid casting. Heating hardened the sand core and melted the thin layer of wax; molten metal was introduced to replace the wax, and when it had cooled the clay was broken away. The hollow casting was finished off with a chisel. In Palestine sand copying was much used in traditional jewellery. The model was pressed between a pair of iron frames tightly packed with very fine sand that had been treated with a mixture of alum, salt and sugar in water. This set and produced an exact impression of the model that could be used as a mould, though only once.

The main decorative processes are chasing, embossing and engraving. **Chasing** is working the metal from what will be the face of the finished object, so that the pattern is indented into its surface. The shaped object is filled within by a mixture of hot pitch and fine sand or ash. Once cool, this core is hard and heavy yet plastic enough to yield to the pressure of

the metal-worker's punch. Alternatively, it might be firmly held in cooled wax; after working, it is removed from the wax by boiling water and then cleaned with soap powder and acid. Flat chasing is used for decorating smooth metal: it involves the use of punches to form linear patterns, rather than a relief pattern, but does not remove any of the metal in the process.

Embossing is the working of sheet metal from behind – the 'inner face' – using round-edged punches to raise a pattern that will stand out in relief on the outer face. The shaped object is now filled with hot pitch and further worked from the front, the outlines of the decorative pattern being chased and the resulting indentations more sharply recessed. By this time the metal is cooler and harder. It may be loosened from the pitch by warming, after which any pronounced relief is beaten out from the inside. On embossed work the silver is often blackened with soot and oil or with sulphur; a final polish of the surface brightens the relief, leaving the indented background dark for contrast. **Repoussé** is a combination of chasing and embossing, and is used to enhance a pattern that has already been embossed from behind.

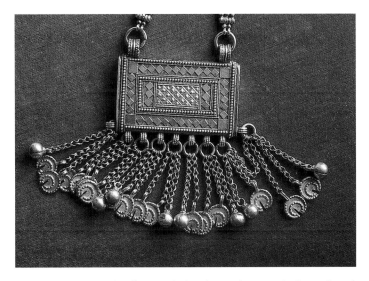

▲ *A side-opening silver* hirz *with danglers and geometric decoration of appliqué squares.*

Used together with engraving it can produce sharply defined geometric and floral patterns.

Engraving is the cutting of patterns in the surface of the metal with a chisel or sharp tool. It is normally done before the piece is given its shape and soldered. The metal may be gouged away in fine chips to produce pierced or fretted work for such objects as

incense-burners. Tools for this kind of work include a variety of fine chisels, known as 'scorpers' and 'gravers', a beaked anvil and flat and narrow pliers; piercing work is done with a chisel or fretsaw. Flint must originally have been used for this work, before the introduction of iron tools around the ninth century BC. A variant of engraving is bright-cut work, using a sharp-pointed tool to cut the metal at different angles so that shallow facets reflect light to produce sparkle (though this often becomes dull with subsequent polishing).

Filigree is the lace-like product of fine silver or gold wire. It is a characteristic of Indian jewellery. Twisted patterns of wire are either fused to the main object, or the wire is shaped into patterns that are then soldered together and to the main piece. The wire itself is produced from thin strips of metal, cut with a chisel and hammered or rolled; it can then be drawn through gauges with a series of progressively smaller holes to make it finer. Hollow wire is produced by twisting the metal round a rod which is then withdrawn.

Wrought metal is achieved by annealing it to make it malleable, after which it can be worked by twisting and bending into the required shape.

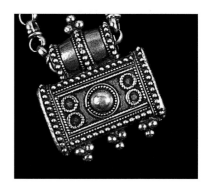

▶ *Small silver phylactery with granulation, including the mulberry shape, worn on a chain around the neck.*

Until the introduction of electrolysis in the nineteenth century, **gilding** was done by coating the object with an amalgam of gold and mercury. When the object was heated the mercury evaporated, leaving a thin film of gold on the surface of the silver.

To clean a finished article and remove surplus solder, white pickling is done, using hot, dilute sulphuric acid or a hot alum solution. The metal is then brushed with pumice powder, Tripoli sand or red oxide, applied either with a coarse brush or a cloth. Jeweller's rouge and burnishing tools made of agate or some other hard mineral are also used. Any marks caused by the raising hammer may be removed by **planishing** with a broad flat-faced hammer.

Chapter 6

DESIGN

THE main decorations on Omani metal-work are floral, geometric and calligraphic – designs familiar to the eye, but developed into artistic, stylised and often exquisite patterns.

A decorative motif, particularly on wide surfaces like big bracelets, is a band of protrusions or bosses interspersed with four or more dots: O:O:O:O. This decoration is similar to the dotted circle found on early Omani pottery – for example, from the Baat graves near Ibri belonging to the Umm an Nar period in the third millennium BC, and round a steatite bowl dating from about 2000 BC from the Wadi Suq graves.

The geometric design and square or diamond patterns are found extensively on silver from Sur and on some pieces from the Ibri area. They are similar to the work of Jewish silversmiths in Yemen, the patterns being embossed or, in the case of appliqué diamond-shapes, cut from sheet silver and welded on. Any *hirz* (phylactery) with these designs is likely to originate in Nizwa. Nizwa also produced a beautiful pattern of stems and foliage of delicate curled leaves. This pattern recalls a design used in China during the Later Liang and Later Tang Dynasties of the tenth century AD, when

Oman had trading links with the Far East. A lozenge-shaped pattern is associated with Rostaq, an area that specialised in annular bracelets and also in bracelets with seals set in their outer surface. Silver with a rose pattern may well come from Ibri, but the pattern is also found on work from Ibra in the Sharqiyah. A design that seems to be a particular feature of the Ja'alan and the Sharqiyah is a linked or overlapping U-shape, which is also prevalent in Yemeni work.

Another common feature is a barrel shaped device (as in this picture) often used to suspend

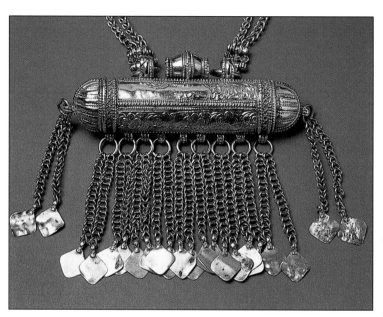

▲ *Cigar-shaped silver* hirz *from Ibri with rose-pattern decoration. The simple square danglers often appear on work from this area.*

coins, or used to attach coins, medallions or other pendants. This is a design of great antiquity, occurring in Mesopotamia in the Early Kassite period (about 1600 BC), on necklaces from Amlash in Iran from the middle of the second millennium BC, and in the fourth century BC on a beautiful gold necklace with pendants from an Etruscan tomb near Todi in Umbria. As a bead, the barrel shape is found in Egyptian jewellery of around 1200 BC and among the Oxus Treasure of 600–300 BC, and it still occurs today in parts of the Arab world and India. In general, beads tend to

take the shape of familiar items like the cowrie shell, the coffee bean, cardamom or maize seed.

Granulation is much used for decoration, either in the form of little balls of metal fused directly to the piece, or of a pyramid shape (*e.g.* as illustrated on page 87) of four or more balls welded together and to the main item. This pyramid shape is a well-known and world-wide symbol of fertility. It is reminiscent of the pomegranate decoration formerly used in Chinese amulets given to a young bride to wish her many sons. The mulberry effect at the bottom of both the *halaq* and *lamiya* ear-rings of Oman is similar to ear-rings found in Cyprus probably Mycenaean origin, dating from 1550–1500 BC. It was also a common decorative device in jewellery from Ur in the third millennium BC and in Ajjul and Megiddo in Palestine in the Middle Bronze Age (2000 to 1500 BC). The motif occurs in Urartian jewellery of Anatolia and the Transcaucasus in the ninth to seventh centuries BC, in jewellery of the same period from Marlik in north-west Iran, Egyptian ear-rings of the Ptolemaic period (304–30 BC) and third-century AD Palmyrene work. Two fine examples of granulation from neo-Elamite graves at Susa, east of the Tigris, from the eighth and seventh centuries BC, can be seen in the Louvre.

Twisted metal – thin in filigree work, or thick for anklets and bracelets – is another form of design used in Omani jewellery that has occurred through the centuries: in Ancient Egypt, in jewellery of the eighteenth century BC at Tel al Ajjul in Palestine, in the Oxus Treasure of the Persian Empire (600–300 BC), and again, much later, in Slav silverwork of the eleventh and twelfth centuries AD.

Embellishment is often added in the form of danglers hanging on chains. This idea dates back to the eighth century BC. It is illustrated in the Achaemenid Treasury at Persepolis; is also found on Cretan pendants and on the jewellery of Rhodes and of Classical Greece.

Omani danglers (illustrated on page 41) may be round, square, triangular, crescent-shaped or hand-shaped. The round shape, suggestive of the sun, is made from two metal discs soldered together. The moon shape (full, half or crescent), popularised by Muslim poets, is often accentuated with filigree and granulation. The hand shape is said to represent the Hand of Fatimah (daughter of the Prophet Mohammed), who is considered an embodiment of all

▶ *Two typical bossed bracelets, one with an opening.*

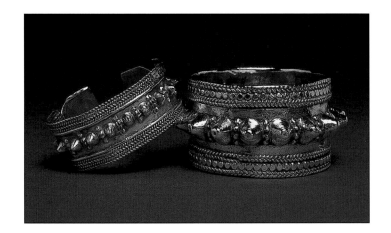

that is divine in womanhood. It is thus deemed to be a good-luck charm. However, the hand (also symbolic to Christians as the Hand of Mary, and to Jews as the Hand of Esther) is a much older device. Around 1370 BC hands were depicted on the ends of the rays coming from the sun disc of the Egyptian Pharaoh Akhenaten at Tel al Amarna on the Nile, perhaps indicating an emanation of power from the Divine. The hand shape also occurs on jewellery of the pre-Hebraic period found at Jericho. Bells, too, may be hung from chains on pieces of jewellery as danglers.

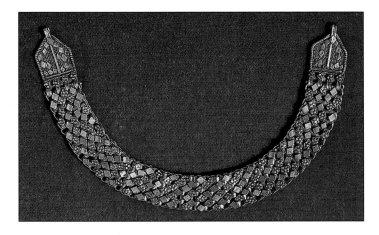

▶*Chain from Yemen showing diamond shapes: the work is very similar to that of heavy Dhofari anklets.*

Chapter 7

The Maria Theresa Thaler

Until recently this handsome coin was the currency in the Gulf area and was often used as a weight for assessing the value of a piece of jewellery. Though no longer valid coinage, it continues to be available in the souks, particularly in Matrah and some of the towns of the interior. It is now most often seen as part of a necklace, called *sumt* or *mazrad*. This has a centrepiece of a large decorated silver medallion, several thalers, possibly one or two phylacteries, and many simple, small beads often strung together. A necklace solely composed of a number of thalers is called *qursh makanna*.

The coin is named after the Empress Maria Theresa, whose likeness it bears. She became Queen of Hungary and Archduchess of Austria in 1740 and died in 1780 – the date on most of the specimens available today. The word 'thaler' goes back to the Joachimsthaler – a large silver coin, first minted by Count Stephan von Schlick in Joachimsthal in Bohemia in 1525. The Austrian Empire was in a favourable geographical position for trade with the Mediterranean and Near Eastern countries and had easy access to silver from the mines of Tyrol and Bohemia. Maria Theresa thalers were first minted in

Vienna in 1751, in response to a growing demand for a large silver coin for commercial and trading purposes. Minting extended to Gunzberg in the 1760s, as demand increased, and it was the engraver here, Baptist Wurschbauer, who cut

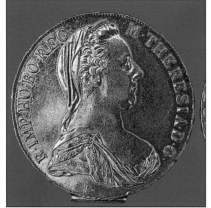

▲ *Maria Theresa thaler dated 1780.*

the original dies for the portrait of the Empress that the coin still bears. (The letters S and F, which appear beneath the Empress's portrait on the standard 1780 thaler, stand for Scholbe and Fabi, the mint-master and warden of Gunzberg.) For the next 100 years the number of mints increased to include Kremnitz, Karlsburg, Milan, Venice and Prague, but from 1866 thalers were minted exclusively in Vienna.

Silver had long formed the general standard and measure of value in the Far East, particularly in China

and India, so the thaler was in great demand in the Middle East for trading with neighbours further east. By the first half of the nineteenth century it was circulating over a wide area, from the north-western coast of Africa, Nigeria, Madagascar and Muscat to the Turkish coast of the Black Sea. The thaler was an ideal coin for trading, since it was difficult to counterfeit or clip, and its standards of weight and fineness were strictly maintained. For countries with no native currency, like those in Arabia, the thaler became an economic necessity. Karsten Niebuhr, the Danish traveller, found the coin already circulating in Arabia during his travels between 1762 and 1767.

Subsequently it became a trade coin with a value determined only by the current price of silver and the vagaries of supply and demand. Demand for the coin

remained so strong that it continued to be minted (bearing the date of Maria Theresa's death) for the next 200 years. Some 20 million thalers were struck in the ten years following her death; during the first twelve years of the present century – when under the name of the *rial fransi*, it was still the principal coin in Oman – over 45 million were struck. Six million were struck by the Royal Mint in Britain between 1945 and 1958.

In 1935 Austria, under pressure from Hitler and Mussolini, was required to hand the dies of the thaler over to Italy, as supplies of the coin were required for use in the Italian conquest of Abyssinia. Thereafter Italy claimed a monopoly of the manufacture of the coin; however, as British interests required thalers for trading in certain British-administered and other territories, including the Arabian Peninsula, the Royal Mint prepared dies and struck the coin in London, perfect in every detail, including the 1780 date. During World War II, in order to save shipping, the working tools for minting were sent to India, where 19 million thalers were minted in Bombay. After the war minting was resumed in London, but sporadically. With the expiration of the Austro-Italian treaty in 1960 minting returned exclusively to Vienna.

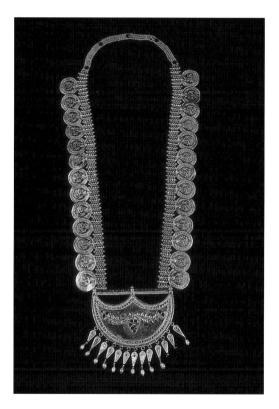

A gold marriya. *This necklace has heavy, intricate chainwork and coins decorated with Arabic script. The crescent-shaped centrepiece* (tafruga) *is embellished with red and green stone (or glass), and small danglers, each ending in a pearl.*

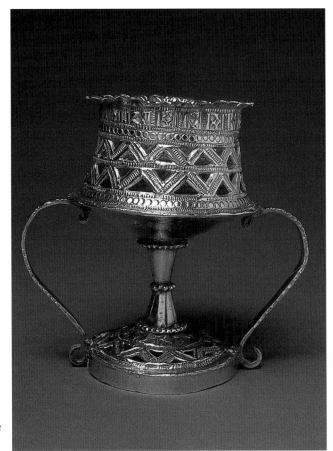

▶ *Simple fretted silver incense-burner from the interior.*

Chapter 8

Everyday Objects of Silver

TRADITIONALLY many everyday articles have been made of silver or richly decorated with it. Old guns and powder-horns often had silver decorations, and small, beautifully embossed silver boxes served as purses. Pipes, tooth-picks, thorn-picks and elegant ear-cleaners (not peculiar to Arabia – they were common in Renaissance Europe) were beautifully fashioned in silver, as were coffee-pots, rosewater sprinklers, incense burners and spikes for making holes in the cloth used for men's embroidered caps. Silver kohl and spice boxes, scroll holders and pen boxes were also often either made of silver or inlaid with it.

In the countryside of Oman's interior, camel thorn is everywhere, and, since formerly few people there wore anything on their feet but open sandals, some means of removing thorns from the feet was a necessary part of personal dress. Most men in the interior used to wear picks and tweezers hanging from their belts. Some of these are made of steel and contained in simple leather cases, but some are of silver and kept in silver cases, often in the shape of a cartridge and sometimes decorated with appliqué gold-leaf. The women's version is similar, though

◀ *A set of tweezers and thorn pick, and a man's kohl pot and application stick, both worn on a belt.*

▲ *Baby's rattle.*
▼ *Silver pipe modelled on the more common wooden version.*

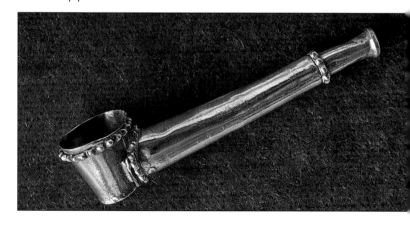

usually less ornate, tucked somewhere into their clothing.

Both men and women in Oman wear the black cosmetic kohl around their eyes. Such a practice is documented in ancient Egypt. It is believed to improve the sight (though passing the same applicator from person to person must have contributed to eye disease). Kohl is a paste made from finely powdered sulphide of antimony mixed with rosewater, or from wood-ash mixed with vegetable oil, or from ghee scented with rosewater. It is kept in a small pot. A man carries his kohl pot, with its screw top and applicator stick, on his belt, often hanging on a beautiful silver chain. A woman's, however, is not made to be worn and is usually an ornate little lidded silver pot (*makhal*), with the stick (*mirwad*)

attached by a chain. As kohl is so widely worn throughout Oman these containers have been made in all the silverworking centres.

Sets of silverwork consisting of a coffee-pot, an incense-burner and a rosewater-sprinkler were until recently made in Muscat and Matrah. Formerly they were in constant use; now they are only used on formal occasions. As a rule, they are beautifully embossed and engraved. After coffee has been served, rosewater (made by steeping crushed rose-petals in water for several days) is sprinkled over the hands, and sometimes over the heads, of the guests. Incense is produced by burning the gum of the frankincense tree or another resinous tree

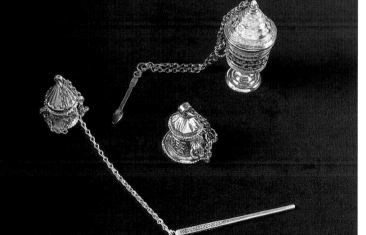

◀ Makhal *and* mirwad.
Left: *A woman's kohl pot and applicator.*
Top: *A lidded silver pot with ornate embossing and a shallow spoon attached by a chain - probably for mixing and dispensing kohl.*

(*luban*), or a sweet-smelling wood such as that of the eastern Indian aloe tree (*'ud*), or a perfumed substance called *dukhan* . It is then lit inside the incense-burner, which is carried round, and the smoke is wafted into the beard and over the body. In the harem the women often put the burner under their clothing so that the aroma lingers about the person.

Oman's traditional coffee-pot is that from Nizwa. Its shape is quite distinctive with a sharply defined waist. Most of the old ones were made of copper with brass embellishments, but modern silver ones in the same style come from Nizwa. A fine example was presented to the United Nations by His Majesty the Sultan in 1973. Based on the style of Nizwa, it is fifty-four inches high and weighs over eleven pounds. Coffee-pots often have little danglers at the base of the handle and under the spout, which are purely ornamental. Sometimes small stones are sealed into the lid. These may simply have added weight to the pot, though some say they were to announce the boiling of the coffee, others that their rattle would give away anyone lifting the lid to add poison to the pot.

▶ *A small silver coffee-pot made in the Nizwa souk in 1972.*

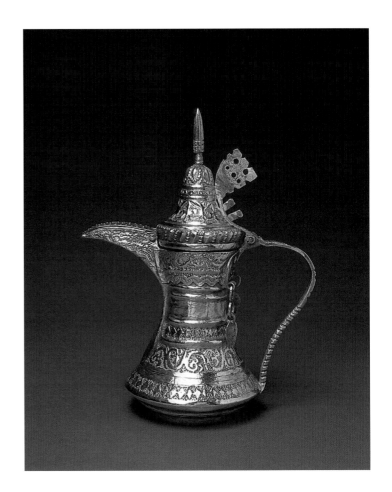

Chapter 9

Jewellery

Necklaces

A wide variety of necklaces is worn throughout Oman, many of the more complicated ones made up of whatever beads or bits of decoration may have been available. One of the most common types carries a *hirz:* a square, rectangular or cylindrical metal box, often opening at one side and containing a piece of paper with an inscription from the Koran or other items to protect the wearer like special wood or leaves. It is often elaborately decorated with appliqué and embossed work – occasionally with a stone in the middle – and has tinkling bells and small silver shapes, flat ornaments or coins dangling from its base on chains. The *hirz* is sometimes incorporated into a necklace comprised of beads, but is more usually simply hung from the neck by a chain that either carries the *hirz* alone or is festooned with smaller silver boxes which may or may not open. Such a chain may also carry silver-mounted bottle stoppers, horn or bone objects set in silver, an animal claw (a lion's being deemed the best protection against the Evil Eye) and little silver figures – all of which probably have amuletic properties. If a *hirz* is silver it probably comes from the interior or the Sharqiyah,

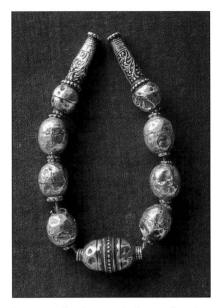

◀ *Silver necklace from the Batinah made of hollow beads with a barrel-shaped central bead. Beads like these also come from Sur.*

Large silver medallions, used in necklaces called *hanhoun*, or *sumt mukahhal*, are also common – these are sometimes richly decorated with gold-leaf. Medallion-wearing dates back to Mesopotamian civilization in the third millennium BC and to the Egypt of the Pharaohs. The medallions strung with Maria Theresa thalers are generally suspended by a decorated barrel-shaped ring, through which the rope or chain passes. The medallions may be treated with palm juice to give the effect of niello enamel. Sometimes the back of a medallion is decorated with three little silver strips at the top, a decoration of no obvious talismanic purpose but found since the Bronze Age.

Necklaces of silver beads date fromthe early Dynastic period in Mesopotamia in the third millennium BC and were common in the Indus Valley civilization and in Troy. Large and small silver bead necklaces still feature in the interior of Oman. Little hollow beads are likely to be from the interior: bigger embossed beads are used to good effect with heavy, complex danglers in the elaborate *manthura*. Batinah beads tend to be larger and simpler (as in the picture). A common form of bead necklace is the *lakdani*, which

but in Dhofar and along the Batinah Coast it may be made of gold. The *hirz* may of course be worn on the forehead. Small girls may well wear a simple necklace consisting of a small medallion with a verse of the Koran actually engraved on the back, hanging on a chain, or a medallion with danglers. A *hegab*, or amulet, is often triangular and may be worn attached to a child's head-dress.

incorporates simple beads interspersed with small coral beads, some barrel-shaped beads and perhaps a straight line along the bottom of bossed and coral beads kept rigid by silver wire. The *lak* beetle of Baluchistan produces the 'pitch' used to fill the beads. Barrel-shaped beads threaded with red beads and silver bossed beads are typical of Baluch jewellery. Sometimes two or three rows of beads, so simple that they look more like tubes of silver cut off at quarter-inch intervals are worn. More than one necklace may be worn at the same time.

Another form of necklace is a wide, flat, silver band, fastened by either a hook or a chain at the back of the neck, perhaps with danglers hanging from it. Crescent-shaped, it is worn by children, perhaps to avert the evil eye. It is called *shabka*, but it occurs elsewhere in the interior and the Sharqiyah, and is also called *tawq*. This

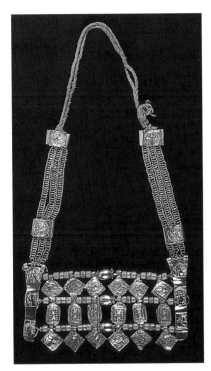

▲ *This* shibgaat, *though worn like a necklace, tends to be attached to the ears rather than hung round the neck.*

shape occurs in other parts of the Arab world, notably Jordan. It is similar to the lunulae of the Early Bronze Age in Ireland, around 1800–1500 BC. These were flat, crescent-shaped neck-rings of sheet gold with terminals twisted at right angles to the plane of the crescent, and with geometric ornamentation. They are also reminiscent of the Broad Collar necklace of Ancient Egypt.

More elaborate forms of Omani necklace have gold-leaf soldered or beaten on to them, and may incorporate coral beads. The use of coral, ceramic, and plastic beads is commoner in Dhofar and in the Sharqiyah than elsewhere. It is common in other parts of the Arab world, notably Jordan and Palestine. Some patterns on the embossed gold-leaf seem to represent people, perhaps to indicate that the gold is from replicas of coins. (In Yemen, gold and imitation-gold coins – possibly copies of

Byzantine coins – are often pressed into the hilts of daggers.)

One richly ornamented style of necklace is worn by the bedu round Thumrait, in Dhofar. It consists of a centrepiece, a wax or wood bead usually covered with imitation coral beads on either side. The heavy, hinged chain on either side of the beads is similar to work done at Nablus, north of Jerusalem, where bracelets in this style are called *habbiyah* (from *habb,* a seed), and the thick plaited work is typical of work from Syria and Turkey. This type of necklace is a good example of a distinctive Omani piece that shows the

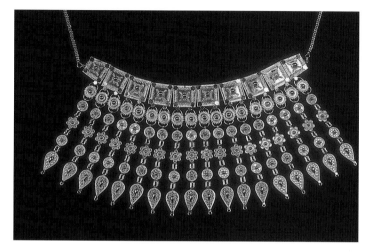

▲ *Gold* mirtasha *suspended on a gold chain. In the United Arab Emirates such heavy pectorals might be decorated with small pearls, rubies and turquoises, either real or imitation.*

◀ *A selection of necklaces and a hairpiece for sale in the souk. The necklace in the centre is a* manthura.

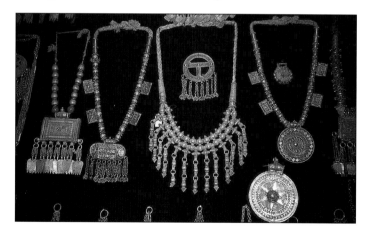

influence of styles from other parts of the Middle East. Large spherical beads, fluted or capped with gold, date back in style to the Early Dynastic period in Mesopotamia, about 3400 to 3000 BC.

Very much a feature of Gulf and Yemeni jewellery

is the *mirtasha*. This is a heavy ornament worn across the chest, consisting of about fifteen metal squares from each of which hangs a series of linked rings, balls, circles and other shapes, terminating in little bells. It is now often copied in gold, (*see* page 58). In the silver version it was often backed with heavy cotton to protect the wearer from the heat that the metal absorbs from the sun. It would sometimes have been worn along the neck border of the dress, hanging down over the bosom and tinkling as the wearer moved (*mirtasha* means 'tinkling'). Other names for this ornament are *mitlazim* (meaning 'stuck' or 'shaped' to the body, as it clings to the chest) or *manthura* ('scattered'). It is very similar to the *kirdan*

worn by the Hajazi women of Syria, Jordan and Palestine. Some consider it to have derived from the chain mail of the Crusades; another possible inspiration is the great pectorals of ancient Egypt.

Anklets and Bracelets

An enormous variety of anklets and bracelets is widely worn in Oman, as elsewhere in the Middle East. These often have little stones inside them that variously tinkle, so that a man may know which of his womenfolk is approaching. Bells on anklets assuredly herald the approach of a woman. The jingle and rhythm bells produce may also have an amuletic significance. Anklets always have a hinged opening,

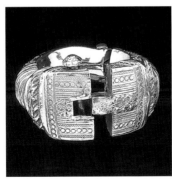
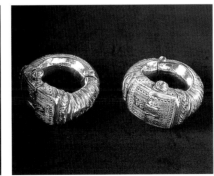
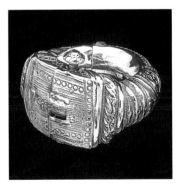

▶ *Heavy Nizwa silver anklets with hinged opening and large silver fastening-pin.*

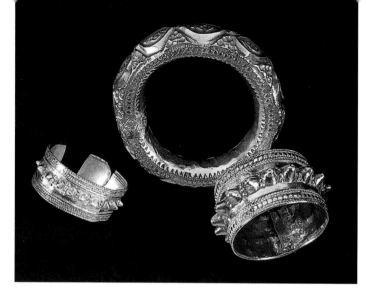

▲ Bracelets
Left: *Simple bossed bracelet with opening.*
Top: *A hollow bracelet from the Batinah, with small stones inside, possible worn on the forearm.*
Right: *A typical Omani bracelet with bosses, now often copied in gold: on a new bracelet the bosses may be very sharp, but there is some indication that they were deliberately worn down to make the bracelet more comfortable to wear.*

whereas bracelets may not; both always come in pairs. Bracelets and anklets are commonly made by forging pure silver into a hollow ring shape, approximately a third of a millimetre thick, and filling it with a mixture of hot pitch and resin. Decoration is done after this has cooled.

Heavy anklets, called *natal* or *ental*, are typical of Nizwa, but are also made and worn elsewhere, notably in Rostaq and Sur. The Nizwa anklet is usually decorated with lines and geometric patterns across the front. It tends to be more rounded than the Sur anklet, which has a flatter face decorated with flowers or geometric design. They open in the centre of the front face and are fastened with a silver pin which, at least on smaller anklets, is often attached by a chain on one side.

Lighter anklets called *hajil*, or *khalkhal*, are normally given to a girl at puberty by her father, and worn until she marries, when they become part of the bridal jewellery. Many children throughout the interior wear little flat anklets. Some, called *hawajil*, or *haboos*, which have bells hanging from them, seem to be inspired by Indian designs. They were traditionally worn by small boys. Another quite common form of anklet is a twist of silver called *weil*, worn by women, which fastens with a loop and pin. A heavy anklet consisting of a wide band of elaborate chainwork, often with bells along the bottom, is more common in Dhofar; it is sometimes called a slave anklet, from the practice of shackling slaves by the ankle, and of showing off

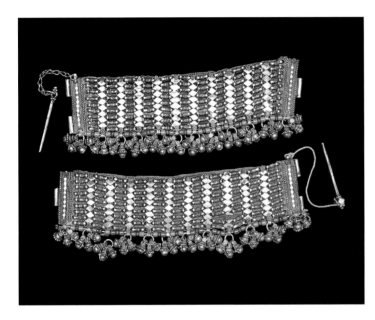

▲ *The anklet* haboos *is a broad band of interwoven chains.*

slaves in East Africa bedecked in jewellery to a prospective purchaser.

All over Oman bracelets are worn. They are called *banajiri* (probably from the Hindi *bangri*), *hajala* or *hayyiy*. The simple, embossed bracelet, about three-quarters of an inch wide, often containing little stones, was made and worn in Muscat, Matrah, and along the Batinah coast. They are identical to bracelets excavated from early copper mines in the Ibri area, but may originally have been Turkoman bracelets dating from 2500–2000 BC have been found in Anatolia. Today, they are found in Baluchistan and Iran.

One of the most common styles of bracelet in the interior is about an inch and a half wide, with a single row of decorative bosses all round and embossed circles along each edge (see page 21). It may also be much narrower, comprising just the bossed decoration on a silver band – in which case several will be worn together, usually five on each arm. These are normally worn by middle-aged women but not by the elderly. They are widespread in Iran and elsewhere. If the bracelet has a double row of bosses it probably comes from Sur or the Sharqiyah; bracelets which open on a hinge are more likely to come from Sur. Sometimes two or three single-bossed bracelets are joined together, so that they cover much of the forearm, in which case they are probably made of very thin silver, delicately patterned and often decorated with gold-leaf. These probably come from the desert areas of Oman and are

much favoured by the bedu of the Dhahirah area as well as those of the Thumrait area in Dhofar.

A heavy three-in-one bracelet called *Abu thalatha* is worn in the Sharqiyah. Bracelets with their ends shaped as a snake's head are almost certainly worn to ward off evil. Among annular bracelets, the round bracelets without bosses, similar to those found in Iran and Iraq, probably come from Rostaq. A round band worn on the upper arm, called *Adhud*, is also sometimes worn, and a hollow, embossed, annular armlet is often worn above the elbow by women, but not by girls.

Ear-rings

The most common form of traditional ear-ring in northern Oman is the almost circular hoop (called *halaq*, or by the bedu *shaqhab*), part of which is usually ornamented and the rest smooth. It normally has one or more silver pendants hanging from it, and a set of dangling shapes on chains, perhaps representing the Hand of Fatimah. The pendants often have a mulberry-shaped design on them. It used to be quite common for young girls to wear four or five of these through holes along the edge of the ear, though they are more often

suspended on chains across the head to hang at ear level. Something very similar to this, but without the danglers, is worn as a nose-ring by the bedu of Beersheba.

A more unusual ear-ring is the *lamiya*: a large, intricate, barrel-shaped pendant with the typical Omani bosses round it, terminating in a triangle of soldered silver beads and an inverted pyramid of small beads. All this is suspended on a hook which can penetrate the ear but is more often hung on a chain and incorporated in the head decoration. Although the *lamiya* probably originates in the Dhahira, it is worn in the Sharqiyah and elsewhere,

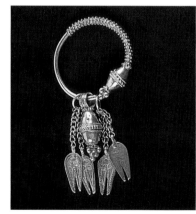

▶ A halaq *either worn directly in the ear or hung, often amongst others, from chainwork.One of its pendants is of a mulberry design.*

▶*A* lamiyah *pendant with typical Omani bosses, terminating in a triangle of silver beads.*

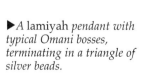

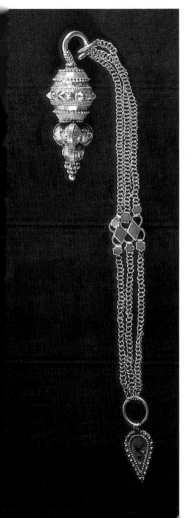

including the United Arab Emirates. The whole headpiece of chainwork and ear-rings is sometimes called *mishill*, although this is actually the name for the silver band on which ear-rings and other jewellery are hung.

Other more complicated forms of ear-rings-cum-head-dress are sometimes found in the interior. These include a set of four long cone-shapes on a chain to hang over each ear, with a central chain terminating in a hooked piece to clip into the head scarf, or a pair of circular hoops embellished with chainwork and hooks. Such elaborate pieces may result from two or three different sets being put together.

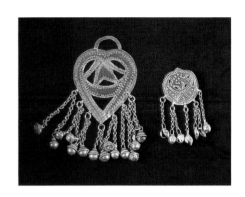

▶ *Left*: A silver hair decoration that jingles with the motion of the body, possibly from Rostaq.

Right: A silver brooch with danglers.

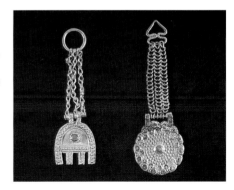

▶ Two head-decorations, called **harf** worn over the forehead attached to either the headdress or to the hair. The round ornament is for girls; the horseshoe-shaped for boys.

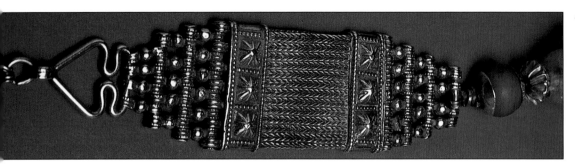

◀ *Detail of fine chain and link-work on a* maknak *necklace. The centre bead is covered in sheet gold (far right), and matching beads on either side are of imitation coral.*

Hair and Clothing Decorations

As well as ornaments being actually braided into the hair, and vast and complicated ornaments of ear-rings being suspended by chains across the head, silver ornaments are often actually sewn into the dress or to form part of the neckline of the garment. The head scarf may also be decorated with silver coins, beads and shapes, sewn to the end. To fasten the overdress, a decorative silver pin may be used, often an embossed diamond-shape. Silver belts, too, are worn, though nowadays gold is likely.

Omani girls often wear their hair plaited in fancy styles, particularly in the Bahla and Jabrin areas. The hair is divided into ten plaits, which are braided halfway down the back into a horizontal plait of

goat's hair; into this is braided an elaborate circular ornament, usually bedecked with danglers or bells, so that it jingles as the girl walks.

Another common form of decoration, particularly around Rostaq, is a dinar or silver coin hanging down over the forehead, attached to a chain tucked into the hair or head-dress. These are worn by little girls, who pass them on to others when they reach the age of six or seven. Little boys sometimes wear a horseshoe-shaped decoration. Both were amuletic and given in early childhood.

The very ornate headpieces that hang down below the head-dress over the forehead are worn for weddings. Nowadays these are likely to be of gold rather than silver. One typical headpiece has gold

chainwork across the forehead, with a piece going down the back and danglers on chains, designed to hold the veil in place while revealing the hair in front. A gold cap, *al Kumma*, is now sometimes worn over the veil, mainly for weddings; it is made entirely of gold with a cloth lining, and is reminiscent of the *kurs*, a round, convex, gold plate about five inches in diameter worn on the crown of the head by Egyptian women in the last century.

An interesting decoration worn as part of bedu dress is the *rai*, consisting of coins and silver beads sewn onto goat hair or leather braiding, hanging down in front of the shoulders like two heavy plaits. The braiding is fastened with the hair behind the ears. Amulets may also be worn at the back of the neck, attached into the head-dress.

Chains

There is a variety of chainwork in Oman, usually made of low-grade alloyed silver for greater strength. Loop-in-loop chainwork of silver wire is the most common. This is made by folding loops of metal in half, then hooking them through one another. Such chain is still made by Oman's silversmiths in Bahla. It

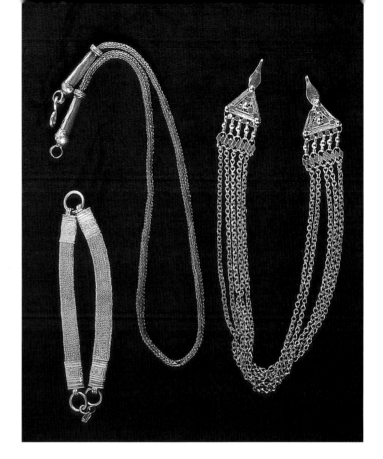

▲ *Chainwork:*
Left: *Double loop-in-loop chain, used to keep heavy earrings and head-ornaments in place.*
Middle: *A more complicated loop-in-lop chain, used as a simple belt.*
Right: *Five strands of single loop-in-loop joined at each end to fastening clips; worn under the chin to keep a headdress in place, called* uqaam.

is widely used for such purposes as keeping in place the head-dress, *lihaf,* when a band of five separate chains is worn under the chin and attached at either end to decorated triangular hooks. It is also used to support small pendants. Rope or string is more usual for heavy pendants and to hold silver beads together.

Looped chain was extensively used in ancient times: for example in jewellery from Ur of around 2500 BC, from Ziweye in Iran of around the eighth century BC, in the Achaemenid Treasury of Persepolis of the fifth to third centuries BC, in Ptolemaic jewellery from 300–100 BC and in the Carthage Treasure of the early Christian era.

A heavier chain, usually half an inch to an inch wide, is used for ear-ring chains and sometimes for belts. This is a double loop-in-loop or square chain, using several lengths of chain interlinked side by side. The first elliptical loop is folded in half. The next link is folded and threaded through the two preceding loops. This double chain can be cross-linked so that it has four, six or even eight faces, to give a herring-bone effect. It probably originated in Ur and was used in Greece from 2200 BC – most famously in the Knot of Hercules diadem, supposed by the ancient Greeks to have healing powers, which was found at Thessaly in the third century BC and is now in the Benaki Museum, Athens.

Rings

Rings are worn by women on hands and feet. While toe-rings are often simple, round rings with bosses, those for the finger are more ornate and designed according to the finger on which they are worn. They are made in pairs, one for each hand. There is a distinctly different ring for each finger and for the thumb. Although by tradition there is no specific wedding-ring, a set of ten rings may be included in the dowry or given at marriage; these are sometimes linked together by chains and to a decoration for the back of the hand, called *qaf.* This is regarded as an Indian fashion and is more common elsewhere in the Gulf than in Oman.

Rings are collectively called *khawatim* (singular *khatim*); the name of each specific ring varies according to the area and whether it is worn by townspeople or by the bedu. The ring for the index finger is called *shahid* (plural *shawahid*), meaning 'witness', and is rounded at the base, tapering to a point over the first joint. The pointed shape is apparently a reminder to the wearer that she must

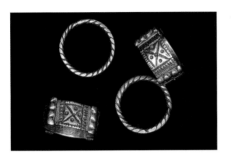

◀ *A pair of Dhofari toe-rings, with the washer-like ring to keep them in place. The big square ring is called* zuqar *and the twisted washer* minthamil.

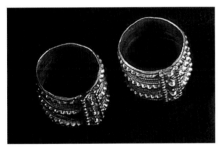

◀ *A pair of thumb-rings.*

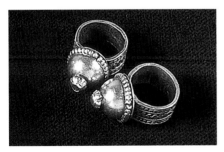

◀ *A pair of rings for the little finger, with small red stones.*

point upward and say: 'There is no God but God'. The decoration on these rings takes the form of engraved flowers, circles and lines.

The ring for the middle finger is called *haisa* (plural *hai'is*). It usually has a round decoration, but can also be diamond shaped. For the next finger there is *khatim abu saith* (meaning 'smooth') or *murabba*, meaning four-sided, i.e. square – its normal shape. It is often of considerable size and decorated with a pattern of squares. For this finger, or the middle finger, there is a ring with a dark red stone (or glass or plastic) sometimes engraved, and set in silver. It is called *khatim abu fuss*. The ring for the little finger - the *haisa* or *shodabiya* – is often the mulberry design of silver beads soldered into a pyramid. There is also a ring with a small bead, often coral or turquise in colour, which is attached through the centre by a silver pin.

Thumb rings, *jabiyrah* (plural *jabayir*), are solid silver bands, with a decorated vertical strip which may have little stones, or bosses.

Most rings appear to be made for purely decorative purposes, but rings with bone or horn set in silver may have special significance and may be worn to protect the wearer against evil. Precious stones do not feature much

in traditional Omani rings, largely because they were not readily available, but *Zar* (or magic) rings are usually of gold with a carnelian set in them. Alternatively, they may have a square decorative base with small granular decorations at each corner and in the centre, built up with filigree to give the impression of the dome of a mosque (as illustrated on page 22). This is reminiscent of twelfth century Byzantine work. The *Zar* is a spirit that inhabits both people and property. Men and women alike wear this ring, to protect them during ceremonies to expel a hostile *Zar.* There is a strong bedu tradition of wearing a *Zar* ring to keep the good *djinns* in. Magic or talisman rings have, of course, been common through the ages, with the Ring of Solomon (or Solomon's Seal) perhaps the most famous.

The most common nose-ring is a stud worn through one nostril, called *badlah.* This is often like a flower, with a central decoration surrounded by six petal-shapes and a small hook passing through the nostril. A ring in a hoop shape worn through the septum is also found. This is called *khizam* or *khizama* and often has fine granulation decoration. It is similar to jewellery found at Ur and in Iran and is mentioned by Isaiah and Ezekiel in the Bible. Some nose-rings

from Sur include a chain and are very similar to those found in India. The ring itself is called *'aws,* but with a chain it becomes *buwlaqhan suriyah* or *umm al-tawariyf* ('mother of twinkling').

Men sometimes wear a silver signet ring, *abu fuss,* on the little finger of the right hand. It was normally decorated with inscriptions, or stars and moon shapes, or with a seal in turquoise or carnelian (or plastic or glass).

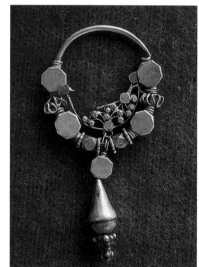

▶ *Silver nose-ring from Dhofar*

Chapter 10

Weapons

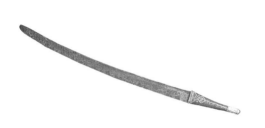

Khanjars, Knives and Swords

One of the first things a visitor to Oman notices is the curved dagger so extensively worn: the *khanjar*. Probably once carried whenever a man was out visiting or travelling, though not used in warfare, it is now seen only at formal occasions and celebrations and is worn by men over the white *dishdasha* (but not with a jacket). Daggers are, of course, also worn in other parts of Arabia, particularly in the Yemen, but the Omani *khanjar* is distinctive, as the tip of the blade has a less marked upward curve. Curved daggers may have been introduced by the Mongols. By the fifteenth century there were two major types: the Turkish *gilij,* with a crescent broadening before tapering towards the point of the blade, and the tapering blade of regular curve of the Persian *shamshir* or Indian *talwar*.

Khanjars are normally given to a boy at puberty, around the age of 13–15, together with his headgear. Today a typically 'Omani' *khanjar* is worn almost everywhere. Formerly, there were distinct regional variations, and the silverwork varied in design not only according to the place of origin but also

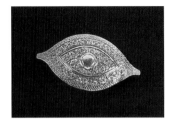

▲ *A simple buckle, perhaps worn by women; it has no fastening but two loops behind.*

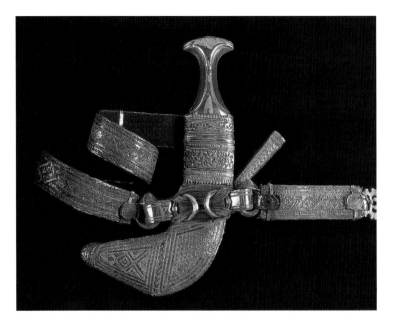

▲ *Silver* khanjar *bought in the Matrah souk in 1972. The elaborate pattern of stem and foliage on the handle and the top of the sheath indicates that it was probably made in Nizwa; the handle is of bone. The leather belt, richly decorated with silver thread, is attached to the* khanjar *and to the decorated silver buckle by means of a long silver band, to which is soldered a coin for decoration. In a leather pouch behind the sheath fits a knife, its handle bound and decorated with silver thread and capped with embossed silver.*

▲ *An ornamental buckle and clasp, worn by boys until they are old enough to wear the* khanjar; *a webbing belt would be attached at one end to a loop on the back of the clasp, and a piece of leather would be stitched to the other end to fit into the buckle (here at the left-hand end).*

according to the status of the wearer. In general, the higher the wearer's social status, the more ornate the work, because both the quality of workmanship and the amount of silver used affected the price.

The best *khanjar* hilts were traditionally made of rhinoceros horn. Occasionally they were made of ivory or buffalo horn. Today, the bone or wood more commonly used – particularly in the Sharqiyah – have been largely replaced by plastic. The pommel is almost flat, or perhaps has a slight curve. However, the Saidi, or Royal Family, *khanjar* has a cross-shaped pommel heavily decorated with silver.

The most important part of the *khanjar,* the blade, is protected by a sheath made of two pieces of wood glued together and covered or decorated with leather, cloth or silver. The leather and cloth may be finely worked with silver thread, and the silver is likely to carry hand-engraved patterns (though these can now be produced by machine pressing). The curve of the sheath used to be decorated according to area and cost. Those from the Sharqiyah on the whole had little ornamentation; those from Sur were often covered with gold and silver thread; the Batinah *khanjar* was

normally richly covered with silver thread or engraved sheet silver. The cap at the tip of the sheath is usually decorated with the same design as the band of silver round the top.

A simple leather pouch is often stitched to the back of the sheath to hold a knife (*sikeen*), which – though probably a cheap and well-worn piece of steel or a kitchen blade – may well have a finely worked handle, decorated with silver thread or embossed silver. (The *khanjar* itself is defensive in origin and now purely ornamental, but the knife is used: during a call on a sheikh in the interior it may well be used for peeling and cutting when *helwa* and fruit are

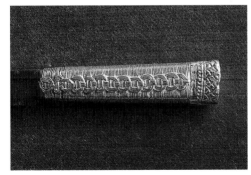

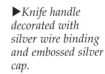
▶*Knife handle decorated with silver wire binding and embossed silver cap.*

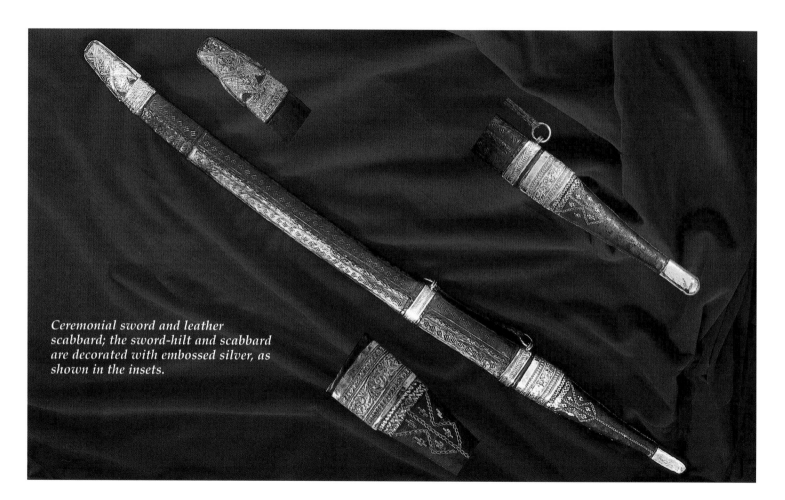

Ceremonial sword and leather scabbard; the sword-hilt and scabbard are decorated with embossed silver, as shown in the insets.

served with coffee.)

The sheath is fixed to a belt by heavy silver rings, two at each side, which are bound to the sheath by leather strapping; up to five more may be added, attached by silver thread. The best *khanjars* have seven rings in all, of which the two that attach the belt and the one at the bottom, attached to the cap at the end of the sheath, are often embellished with a silver cone for decoration.

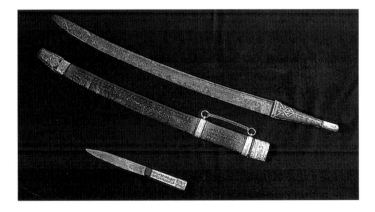

▲ *Ceremonial sword, with its scabbard; and knife, with the handle of embossed silver and silver thread.*

The belt on which the *khanjar* is worn can be made of materials ranging from simple webbing, sometimes interwoven with silver thread, to beautifully ornate leather, finely embroidered with silver wire and fastened by silver buckles. Some belts may have a pocket over which is sewn an engraved silver cover, called *Beit Mahzam*. (Also attached to the belt may be a *mdharba*: a chain with a piece of cotton on one end and a piece of metal on the other – striking the metal on stone produces a spark to light the cotton, and so start a fire.) Smiths in Rostaq copied small silver belt buckles by clamping the specimen to be copied between two pieces of cuttlefish shell. They then removed the original buckle, reassembled the mould and carved a small channel through which it was filled with molten silver. Since heat damages the shell, a fresh mould had to be made for each piece of casting.

Swords were regarded by early Arab poets as the trusted companion of the desert rider. But they are much less common than *khanjars* or rifles. It is probable that they were regarded as a treasured possession of the wealthy and powerful, and largely

confined to the nobility, as in other countries. There are two indigenous types of sword: the straight *saif* and the curved *kitarah,* the latter appearing, with the *khanjar,* on the Omani coat of arms. Many of the *saif* blades are very old – indeed some of those used in traditional dances are said to have been captured from the Portuguese in the sixteenth century.

There are some fine examples of old swords are still used ceremonially. Many have very flexible blades that are shown to great advantage in traditional dances on ceremonial occasions and at celebrations for *Eid* and weddings. In these dances – which owe their origin to war dances – the performer holds the sword in one hand, its thin, double-edged, three-foot-long blade vibrating to the rhythm of the beating drums and hand-clapping by the onlookers, and at intervals throws it high in the air and catches it. In the other hand he holds a *turse* – a small, conical shield made of rhinoceros horn from East Africa, often tipped with silver.

Sword blades were normally imported, mainly from Europe. They were then made into complete swords, with fine hilts and scabbards often richly decorated with silver and/or gold. The decoration was particularly fine when the sword was intended as a gift for an important visitor.

Both *saif* and *kitarah* have the same hilt, which is normally of wood covered either with silver thread wound round and round it, often forming a pattern, or with interwoven silver and leather. The scabbards are of wood covered with patterned leather. (The pattern is created by winding string round the wooden frame on which the wet leather is stretched; as it dries the leather takes the impression of the string.) They may subsequently be decorated with silver or gold thread and an embossed silver or gold decorative tip.

The Shihuh Axe (Jerz)
A weapon that is a striking feature of the Musandam Peninsula in northern Oman is the *jerz*: a long-handled, small-headed axe of distinctive shape, perhaps owing its origins to bronze axeheads of the second millennium BC. The nature and isolation of their terrain have made the Shihuh of the Musandam an independent and warlike race, and it is not

unknown for the *jerz* still to be used in fighting. Like the *khanjar* of the rest of Oman, it is part of formal dress, but it also serves as a walking-stick, a means of self-defence and as a carrying pole over the shoulder.

The shaft is typically 83 cm long, made of a local wood such as *sidr* (Christ Thorn) or bitter almond, and often decorated with incisions. It may have a metal cap to protect the end and a metal collar at the top, before it narrows to take the axehead. The head is about 10 cm long and narrows from 3.5 cm at the blade end to 1.8 cm at the shaft end.

The *jerz* may be very simple and undecorated; it may have incised geometric designs; or it may be inlaid with decorated brass. The amount and style of decoration appears to reflect the purse of the person

▲ *Shihuh axe (jerz) from Musandam.*

who commissioned it, rather than any tribal or regional requirement. *Jerz* are still made to order and to the purchaser's design, using scrap steel and the brass from spent cartridges for any inlay work. Crossed *jerz*, like the crossed swords and *khanjar* elsewhere in Oman, are sometimes used as a decorative device.

Guns

When the Portuguese came to Oman in the sixteenth century they brought with them new style weapons, including guns. By the eighteenth century guns – most commonly the muzzle-loading matchlock *(abu fatiylah* or *gizail)* – had become prized possessions and were often carried as a status symbol. The barrels were imported, often from India, but the stocks were carved and decorated in Oman, with silver, brass or even gold inlay, added as plaques or wound round in the form of wirework. In the second half of the nineteenth century the breech-loading Martini Henry rifle appeared in Oman, and was often embellished locally with silver, the most common decoration being rings round the barrel and bands to hold the sling. As

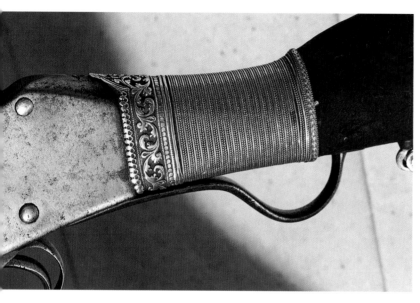

▲ *The decorative banding round the stock of a Martini Henry.*

▲ *Wooden powder-horn with silver cap.*

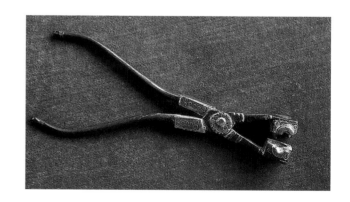

▶ *Bullet mould; resembles pincers with a hemispherical hollow in the face of each jaw. Molten lead is poured into the closed mould through a small channel. When it has cooled the pincers are opened to reveal a spherical ball.*

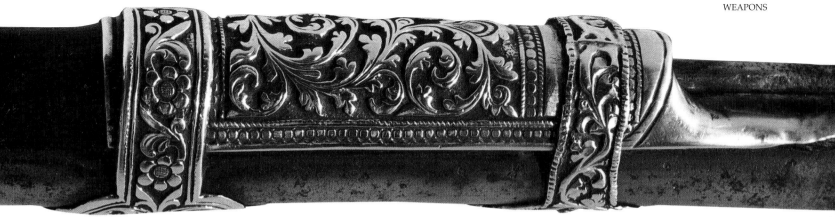

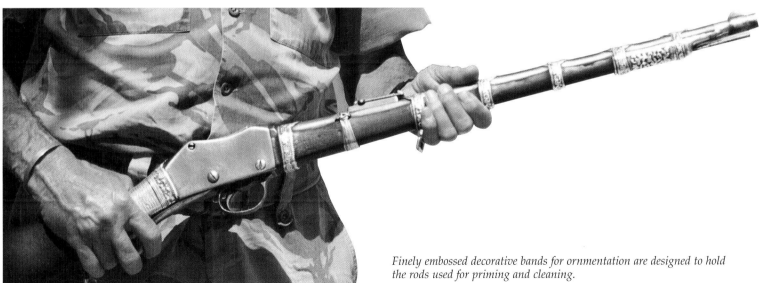

Finely embossed decorative bands for ornmentation are designed to hold the rods used for priming and cleaning.

a result of the increasing number of Europeans in Oman in the twentieth century many of these guns have now left the country as collectors' items, though some fine specimens can be seen in the Oman Museum.

Gunpowder (made of equal quantities of sulphur, charcoal and saltpetre) was kept ready for use in a powder-horn, worn on a leather strap. From this it was carefully measured into the barrel of the muzzle-loader with a special scoop (sometimes attached to the powder-horn, *qara*, by a silver chain) for the ball to be similarly rammed down and compacted with wadding before the bullet was similarly rammed down and secured. Powder-horns vary widely in design and value, the simplest type being a plain wood or horn object (sometimes literally a horn, such as that of a gazelle) often with a silver end. The larger wood or horn *qara* is often decorated with silver or brass, while the beautiful *talahiq,* as made in Persia between the sixteenth and nineteenth centuries, is an ornate crescent of silver, often decorated with gold.

By the late nineteenth century a wide variety of weapons, including rifles and carbines from Switzerland, France, Belgium, Austria, Holland, Turkey and Britain, were available in Oman, and Muscat became the chief arms emporium of the Middle East. The Khojah merchants of Matrah were much involved in the arms trade in the 1890s, and other important ports involved were Sohar and Masna'ah on the Batinah, with caravan routes to Nizwa and Rostaq. Some of the arms went to the interior, but more went on up the Gulf by sea. In 1899 95 per cent of imported arms were re-exported, a trade which produced not inconsiderable customs revenue for the Sultan.

Chapter 11

DHOFARI SILVER

REGIONAL differences in craft and jewellery design are marked, particularly between Dhofar, the southern region of Oman, and northern Oman. Dhofar's stylistic affinities are with Yemeni work. This is not surprising. Both territories have long-established seafaring contact with Somalia and Socotra, tended to look west for trade, and there were always close links between the Hadramaut and Dhofar, not only along the coast but also inland, along the old incense routes. Similarities are noticeable also in costume. Women of the Hadramaut wear the same style of dress – trailing at the back but shorter in the front – as the Dhofari plainswomen. However, Dhofar also had strong trading links with India, which are reflected in its style of jewellery from the nineteenth century onwards. Cog-shaped beads and heavy chain anklets with bells along the bottom were common in India, and the flower-petal decoration of finger-rings features in jewellery from Rajasthan.

The jewellery of Dhofar is generally more solid and uses noticeably more beadwork than is common in northern Oman. It features thick, chunky beads and is often decorated with coral or imitation coral, or even plastic. (Beads were used as a trading commodity

with East Africa, when Zanzibar was the capital of Oman's empire there.) However, Dhofar is a poor and sparsely populated region and itself made up of distinct areas. The jewellery of the fertile coastal plain around Salalah, long permanently settled and in contact with both the outside world and the hinterland, differed from that of the Jebalis (largely cattle herders) in the mountains behind the plain, and from that of the desert areas beyond, where much of the population was nomadic. The names of pieces differed too, and continue to differ, according to linguistic group. Away from the coastal areas the people would have been too poor to use anything but bone or shell for beads, and iron for amulets. Coastal jewellery would, wherever it could be afforded, have been made of silver. Today gold is extensively used, and silver jewellery only made up on request.

In Salalah there are still two smiths making silver *khanjars*, knives and swords. The goldsmiths are now Indian, mainly making to order and following styles and designs dictated by current fashion. Those few women who have been involved with silvercraft have worked mainly in marketing rather than making, although there are now women Indian goldsmiths as well. They have the advantage over their male fellow-craftsmen in that they can visit their female customers in their homes to discuss their particular needs. Much of the work remains traditional in design (often directly copying in gold what was formerly made in silver), but new styles are appearing, drawn from Indian designs. Though of fine workmanship the objects are slighter, and therefore usually cheaper, than those of traditional design. As in the north, copies in gold of the national emblem, the crossed swords and *khanjar*, are popular pendants and brooches.

What little gold there was before 1970 was reputed to have come from Somalia, or else it was imported by the wealthy merchants in Sur. It is remembered only in the form of nose-rings or studs worn by some of the wives of the wealthier merchants in the coastal settlements. Gold coins would have been occasionally bought, and at little cost melted down and turned into whatever the wearer wanted. A few pearls were found offshore, and others brought in from Sur or further up the coast, but they were not extensively used in traditional Dhofari jewellery.

F.M. Hunter, in his *Account of the British Settlement*

of Aden in Arabia (1877), says that the traditional items of jewellery in the area included a nose-ring, ear-rings, necklets, armlets, wristlets, finger-rings, toe-rings, belts, anklets, and a hair decoration of gold coins hung on silk cords woven into the hair. Many of the items he describes are identical to jewellery found today – including the *marriya* (a necklace with alternate coral and filigree gold beads), a necklace of plain and hexagonal gold beads, the flat, oblong *hirz*

containing verses of the Koran and worn as an amulet, bracelets (*banajari*) of chased metal, usually an inch wide and with irregular projections resembling thorns in the middle, and silver anklets (*jinghani*) about an inch wide, resembling chain mail, with bells hanging along the lower edge. The pearls were unset; gold, silver and plate were used, much of it imported from England, Hong Kong, Al Luhayya and Massawa and some of it exported to Bombay.

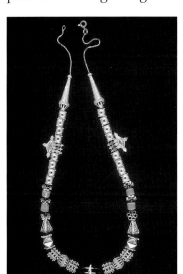

◀ *Traditional Dhofar* **marriya** *with a series of gold beads threaded on a gold chain. Coral beads are added for interest, and the central black-and-white bead would originally have had amuletic properties.*

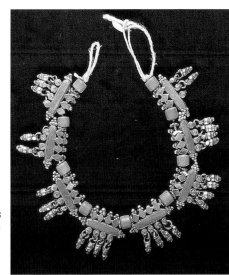

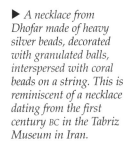

▶ *A necklace from Dhofar made of heavy silver beads, decorated with granulated balls, interspersed with coral beads on a string. This is reminiscent of a necklace dating from the first century* BC *in the Tabriz Museum in Iran.*

Hunter describes most of the jewellery as being Jewish handicraft and 'not very excellent', though there were also a few Indians working. According to Lewcock and Sergeant, Jews did not have the monopoly of silverworking in the Yemen, but it must be assumed that they had been working silver there for centuries. Because the craft involved working with a customer's property on commission, it was highly rated work, and pieces would be marked with the smith's name. After the mass exodus of Jews from the Yemen, earlier last century, some Jewish goldsmiths and silversmiths came to Salalah, including those who had been apprenticed to Indian smiths in Aden. However, they are remembered in Dhofar as working to Dhofari designs rather than having brought their own styles and patterns with them.

With Dhofari, as with northern jewellery, the designs are often reminiscent of jewellery of earlier times. For example, the twisted-metal bracelet, *mhadabit*, resembles designs of ancient Egypt, the Oxus Treasure and work of the tenth and ninth centuries BC from Marlik; the *malnaut* (illustrated on page 86), a bracelet of cog-like beads interspersed with solid beads, is similar to a Roman gold bracelet in the Amman museum; and long, cylindrical earrings with a granulation decoration are like jewellery from Ziwiye in Iran that dates to 800–500 BC.

As elsewhere in the area, silver was used in times of prosperity, and when available, to decorate a wide variety of objects, including such things as circumcision-stick-supports and the leather *cache-sexe* worn by some of the desert girls. Cradles, of goat or cow skin draped over sticks, were often decorated with silver danglers and rattles. It was considered desirable to adorn a newborn child with tiny silver anklets and, in some parts, with a single silver earring and nose-ring. Small girls wore a medallion hanging down on the forehead, or down the back of neatly plaited hair, and a silver tag tied into a knot of hair on top of the head – unless the family was too poor to afford more than the henna representation of such an ornament. If there was enough money, the next thing would be a necklace of a few beads on a string round the neck, with perhaps one round central bead.

Although a girl veils from before she is legally marriageable, she probably wears adult dress only after marriage. By that time she would expect to

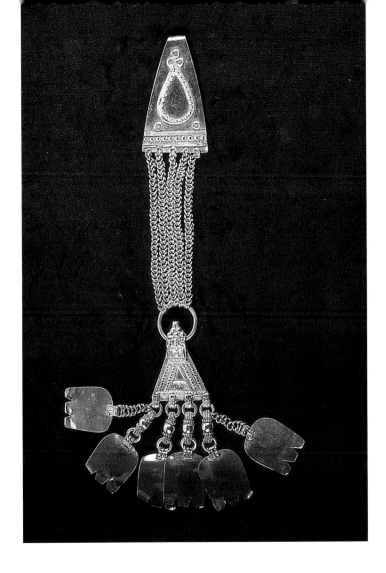

possess the head-tag, a nose-ring, the traditional *marriya* necklace, a bigger necklace (with a central circular disc and other disc-shaped ornaments on barrel-shaped rings, interspersed with gold and coral beads), various head-dresses and a toe-ring set. For her wedding a bride would beg or borrow from friends and relations every bit of jewellery she could, keeping it for the week or so of the celebrations, as has been the custom in this part of the world for centuries. Long afterwards she may remember the excessive weight on head and neck. A wealthy Omani bride from the south might well wear two *marriyas* together; a central nose-ring decorated with a cog-like bead; a long necklace of beads of the cog design on barrels alternating with coral beads; a *qaf* on each hand; and on her head a decorated band of gold with coin shapes on the forehead and round danglers down the side of the head. Subsequently she might buy jewellery for herself with money she was given or

◄ *A long silver hanging piece from Dhofar. It is clipped on the dress just below the shoulder by women of the Mahra tribe (a similar piece made of camel bone might be worn by poorer women). The triangular shape (which is often considered amuletic) towards the base is covered with gold leaf and hung with Hand of Fatimah danglers.*

earned.

Little boys would be given a pair of anklets and bracelets, (usually simple silver bands), a necklace with phylacteries and, possibly, a single ear-ring. At puberty a boy becomes entitled to wear a *khanjar,* with as ornate a belt as the family can afford, and possibly a silver signet ring.

Amulets

Amuletic pieces tend to be made of a combination of plant and animal materials and iron, rather than gold or silver. They vary from area to area, and are given or lent during illness and childbirth. Traditionally, certain pieces of silver and coral were probably worn by a mother during the forty days after childbirth. Such was the custom in the Yemen. As in northern Oman, fox or hyena teeth enclosed in silver are considered amuletic. Although iron was generally the chief substance for amulets in Dhofar, individual iron pieces may be decorated with silver – for example a toe-ring worn by child-bearing women and a bicep ring worn by men. A man's single silver or iron ear-ring is regarded as an amulet, as is a child's nose-ring, if still worn. The gold or silver *hirz* is, in Dhofar, worn only during an illness and is removed once the child recovers.

In the desert areas coral and ambergris are regarded as amuletic, and the black-and-white central bead of many necklaces, including the *marriya*, is considered to bring good luck. The Jebalis regard substances like iron, tobacco, and garlic as amuletic and wrap leather round them, or round a piece of writing, and place them somewhere amongst their clothing. It is interesting to compare this use of garlic with customs elsewhere: in parts of south-east Asia garlic may be placed in trees round a garden, or worn on the body of someone wishing to keep rain away from an outdoor event, and in Europe it is generally regarded as health-promoting.

Necklaces and Beads

Heavy chainwork (*silsila*) is used to make up a typical piece of coastal jewellery, with intricate and distinctive links called a *manjad* (a word very similar to the *jnad* of Jordan). Married women wear it over one shoulder and under the other arm, but under their clothes, so that the beautiful workmanship is

barely visible. Some say it is associated with fertility. (In Kurdistan such a piece is regarded as an amulet.) Another type of *manjad* is found amongst the bedu of the Qara mountains. Worn in the same way, it consists of three strands of silver chainwork joined at two- to three-inch intervals by silver shapes of spades, hearts and clubs.

Some of the necklaces extensively worn in northern Oman, particularly in the desert areas, are also found in Dhofar, for example, a silver choker made up of chains with a circular band to keep them in place. The most distinctive gold necklace of Dhofar, however, is the *marriya*, worn mainly around Salalah. It is made

▼ *A Manjad.*

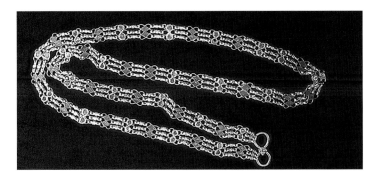

up of solid or filigree gold beads, which may be round, cog-shaped, cylindrical or lozenge-shaped, interspersed with coral beads and has a central black-and-white bead to ward off the Evil Eye. The beads are threaded on a simple gold chain. It is reminiscent of necklaces of gold, carnelian and onyx beads from ancient times in southern Arabia, found by Brian Doe during excavation of the Moon Temple at Huraidah and at Ghaibun in the Hadramaut. Doe describes what little jewellery remains from ancient south Arabia as generally of a very high standard of craftsmanship. He states that 'pubished reports on these beads indicate that they show a distinct eastern Mediterranean influence datable between the eighth and sevenths centuries BC.' The jewellery uses techniques used in pre-dynastic Egypt, and is similar Roman jewellery of the AD first to third centuries, which was probably imported during the early years of the Christian era when the technique of granulation was obviously well developed, and when sophisticated ornamental pieces for necklaces (including filigree work) and necklaces of gold pendants were being produced to a very high standard similar to that of modern Dhofari work.

The coral in Dhofari jewellery probably came mainly from local waters. Beads, including mock-coral, are said locally to come from India, as are the glass beads, sometimes referred to as 'jewels', that are incised and otherwise worked locally. (It is difficult to be sure of the provenance of particular beads, though, because older Dhofaris describe anything from abroad as coming from India.) The central black-and-white bead of the *marriya* might be polished sea shell or stone, but (in Dhofar as in Yemen) it is called a 'Mecca stone', so it might also come from Sana'a where agate, carnelian and other stones were found and worked. It seems identical to that described by Freya Stark in *The Southern Gates of Arabia*. Describing the beautiful gold beads of a lady from Makalla, she refers to 'a striped sort of stone in the centre, called *Sawwama*, which the bedu bring from the desert' that every woman liked to wear as a sort of talisman, and for which they were prepared to pay a high price. The description indicated similarities to the Tiger's Eye bead of some Himalayan states and the greyish-white spherical bead of agate regarded as amuletic by the Kurds.

A peculiarly Dhofari use of small beads is a complete covering for a horn or bone kohl pot (ilustrated on page 93).

Bracelets and Anklets
One of the most distinctive types of Dhofari

▼ *Two bracelets from Dhofar:*
 Left *A* malnaut *with cylindrical coral beads.*
 Right: *A* mhadabit, *reminiscent of Egyptian twisted-gold bracelets dating from 1500 BC to AD 100.*

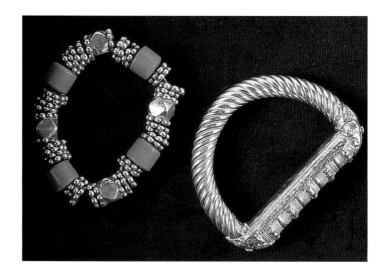

bracelet is the *malnaut*, made up of heavy, square silver beads with a round, cog-like decoration at each end, then four cog-like beads, then a cylindrical coral (or imitation coral) bead, and another set of cog beads; this sequence is repeated four times and threaded on a string. Also typical is the *mhadabit*, the Jebali name for a surprisingly heavy D-shaped bracelet. Its curved part is of heavy, twisted silver that looks as though it has been fashioned around rope, while the straight side has the bosses so often found on silverwork, and a decoration of silver thread. These two types of bracelet, always made in pairs, are also usually worn together. Other names for all-silver Dhofari bracelets are *sukayliyt* and, for the coral-and-silver bracelet, *manaynah*. In addition to these there are the usual plain bracelets, with bobbles rather than bosses for decoration, worn both by plainsfold and Jebalis.

Anklets tend to be confined mainly to the coastal area. They usually consist of a wide band of elaborate chainwork with dangling bells, called *khalkhal* (alternatively *haboos*). They were worn largely by former slave women, and are regarded as rather degrading by Jebali women.

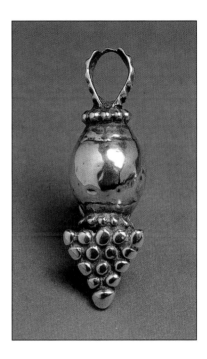

▶ *Small silver pendant, such as might hang on an earring complex, showing granulated-ball mulberry decoration.*

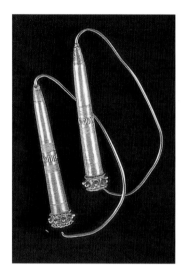 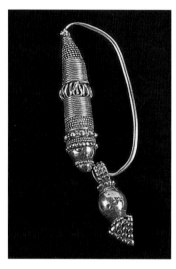

*Silver earrings from Dhofar. The pair on the **left** are very typical and, rather than being hooked into the ear lobe, they may be suspended from an ornate chain headpiece to hang at ear level (the cylinder is hollow, so they are quite light). The earring on the **right** may come from the Dhahira area; the inverted pyramid finial at the bottom, made of granulated balls, is reminiscent of an Egyptian gold earring of the Ptolemaic period(304-30 BC) and of the gold earring of a seventh-century Alanic woman found in the north Caucasus.*

Ear-rings

Large, long, conical ear-rings, though a feature of Dhofar, are also worn by women in the Dhahira area and in parts of the United Arab Emirates. The cone is attached to a large silver loop which goes through the ear. Alternatively, several may form part of a more elaborate head ornament with extensive chainwork. Such conical ear-rings occur anciently – in Nineveh.

Also quite common is a D-shaped ear-ring, which often has a coral bead on its simple, straight side.

Hair Decorations

A silver hair decoration characteristic of Dhofar is made up of a set of ten cone-shaped pendants, each with eight to ten little bells hanging from it on chains. These are normally hung in wool which is interwoven with the hair and are called *'athkol* (singular *'athqul*) or *athkuwar*. This decoration does not occur in the mountains, unless specially borrowed for a wedding.

Married women often wear a small rectangular head-dress or cap with embroidery and silver ornaments stitched to it. It may be ridged with coins and silver semi-circles, or it may be a piece of cloth with long cylindrical beads sewn along the side and a decoration with danglers at the back. Single girls wear the latter type with six cylindrical beads, three on either side, while married women have ten beads.

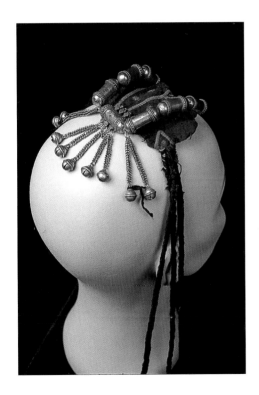

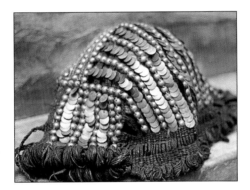

▲ *Goatskin headdress, probably from the Ibri area, covered with silver discs and spherical beads. It is called a* shabka.

◀ *Dhofari headdresses –* kharaka *– of varying styles.* ▶

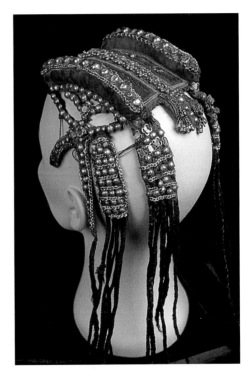

These head-dresses compare interestingly with the *saffia* or *saffifa*, worn in Palestine, which consists of a mass of coins attached to a cap, held firm by seven silver chains under the chin.

There are other Dhofari forms of cap, in both gold and silver, often intricate, and worn for such celebrations as *Eid*, weddings, births and circumcisions – both in the mountains and on the plain. The simpler ones include a head-dress with little rounds of silver in three rows and down the strings that hold it on, and a leather and silver cap. Small girls used to collect goat skin and cut it into strips which they plait and attach to a leather net to wear in their hair.

More sophisticated is the gold cap, *al kumma*, worn

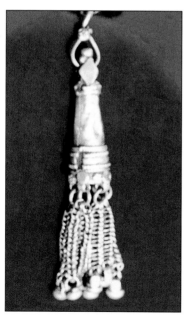

▶ Muthalatha *or* sils - *a typically Dhofari decoration tied to one corner of the headdress and placed over the shoulder. It is believed to be a symbol of fertility.*

◀ *An 'athqul - one of a set of ten worn in the hair.*

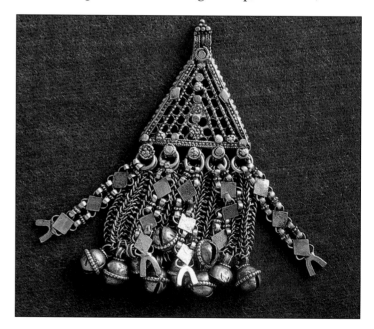

over the veil, which consists of gold ridges with a flat central portion and triangular side sections, with hanging chainwork and a coin over the forehead. This is copied and worn outside the region.

Another typical Dhofari head-dress is the *sils,* a heavy small triangle of finely decorated silver. Along the base there are usually five rings, each holding an elaborate interlinked chain terminating in what might be a representation of the human form, and thus probably a fertility symbol. Behind the five rings there are usually a further five, each holding a simpler chain that carries a jingling bell, with perhaps a row of coral or plastic beads (nearly always red and/or green) threaded on wool between the chains. The *sils* is worn attached to the head scarf (*lihaf*). Keys were often carried in the same place, and it is possible that the *sils* was worn to hide the keys.

Rings

Finger-rings vary slightly in design in Dhofar from those of northern Oman, tending to be more solid. A typical Dhofari finger-ring has a four-petalled flower of silver for decoration. There are also sets of silver toe-rings. Traditionally an iron ring covered with

silver was worn on the big toe throughout labour and for forty days afterwards, to protect both mother and child from the Evil Eye. A square toe-ring was regarded as special, and is worn on the big toe often with a simple band of twisted silver to keep it in place, rather like a washer.

Jebali women tend to regard the wearing of toe-rings, except on the big toe, as degrading, associating the style with slave status.

In his excavations in southern Arabia, Brian Doe found nose-, ear- and finger-rings very similar to those worn today in Dhofar.

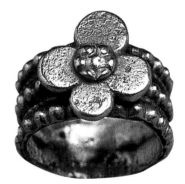

▶ *Dhofari ring with typical flower-petal decoration.*

Ornamentation Worn by Men

Now that gold is both popular and readily available, many Dhofari men have taken to wearing gold rings and watches, and some of the descendants of former slaves wear chains with gold pendants round their necks. However, Islam imposes certain restrictions on the wearing of precious metals by men, so that – apart from the *khanjar* – men would normally wear only a single silver signet ring (often called the Muslim ring) and possibly a single ear-ring.

A form of male adornment that was seen until recently in Dhofar was a long 'rope' to bind up the hair, made of tiny, plaited strips of goat skin, which might be embellished with silver danglers, and elbow bangles.

▲ *Horn kohl bottle from Dhofar, entirely covered with small beads; it has a long metal applicator stick attached to the inside of the lid.*

Bibliography

Al Jadir, Saad: *Arab and Islamic Silver* (London, Stacey International, 1981).

Apex Publishing: *A Tribute to Oman.* A variety of articles from which, over the years, I have absorbed various facts, particularly those from R.I. Richmond.

Arrian: *The Erythrean Sea*, trans J.W. McCrindle (London, Trubner, 1879).

Belgrave, Charles: *Pirate Coast* (London, Bell, 1966). *Personal Column* (London, Hutchinson, 1960).

Bibby, Geoffrey: *Looking for Dilmun* (London, Stacey International, 1998).

British Museum: *Jewellery through 7,000 Years* (London, 1976).

Carter, John R.L.: *Tribes in Oman* (Peninsular Publishing, 1982).

Costa, Paolo M.: *Musandam* (Immel Publishing, 1991). Journal of Oman Studies - various articles.

Colyer Ross, Heather: *Bedouin Jewellery in Saudi Arabia* (London, Stacey International, 1978). *The Art of Bedouin Jewellery* (Arabesque, 1981).

Dickson, H.R.P.: *The Arab of The Desert* (London, Allen & Unwin, 1949).

Doe, Brian: *Southern Arabia* (London, Thames and Hudson, 1971).

Doe, Brian:*Monuments of South Arabia* (Cambridge, Oleander, 1983).

Firong, Iran Ala: *Silver Ornaments of the Turkoman* (Hamdani Foundation, 1978).

Hansen, Henny Harold: *The Kurdish Woman's Life* (Copenhagen, Nationalmuseet, 1961).

Hawley, Sir Donald: *Oman and its Renaissance* (London, Stacey International 1998).

Hayward Gallery: *The Arts of Islam* - from The Hayward Gallery, 1976 (Published by Arts Council of Great Britain).

Hughes, Graham: *The Art of Jewellery* (London, Studio Vista, 1972).

Hunter, F.M.: *An Account of The British Settlement of Aden in Arabia* (London, 1877).

James, T.G.H.: *An Introduction to Ancient Egypt* (London, British Museum, 1979).

Kunz, George Frederick: *Rings for the Finger* (Mineola, NY, Dover Publications, 1973).

Lewcock, Ronald and **Sergeant,** H.B. : *Sana'a: An Arabian Islamic City* (World of Islam Festival Trust, 1983).

Lorimer, J.G.: *Gazetteer of the Persian Gulf, Oman and Central Arabia* (Calcutta, 1915).

Maxwell-Hyslop, K.R.: *Western Asiatic Jewellery c. 3,000-612 BC* (London, Methuen, 1971).

Miles, S.B.: *The Countries and Tribes of the Persian Gulf* (London, Frank Cass, 1919).

Murray, M.A.: *The Splendour That Was Egypt* (1949). (London, Sidgwick & Jackson, 1957).

Philby, H. St John: *The Queen of Sheba* (London, Quartet, 1981).

Phillips, Wendell: *Unknown Oman* (Harlow, Longmans, 1966).

Stark, Freya: *The Southern Gates of Arabia* (London, Murray, 1936).

Ward, Philip: *Travels in Oman* (Cambridge, Oleander, 1987).

Weir, Shelagh: *The Bedouin* (World of Islam Festival Publishing, 1976).

Index

(Illustrations are indicated in bold type)

ambergris 37
amethyst 23
amulets 18, 22, 21, 23, 24, **25**, 26, 36, 38, 45, 65, 80, 81, 84
anklets 14, 15, 21, 25, 28, 29, 30, 45, 59, 60, 86, 87
 jinghani 81
 khalkhal 60, 79, 81, 82, 84, 87
 natal 60
 padink 29
 weil 60
annealing 39, 42
Arabia Felix 13
armlets 62
Asia Minor 11
Assyrians 24
badlah see rings
Bahla 16, 64, 65
Baluchistan 20, 33, 57, 61
banajiri see bracelets
Batinah Coast 56, 71, 78
beads 12, 18, 19, 21, 27, 34, 38, 44, 47, 55-58, 79, 80, 83-88
 agate 38
 glass 86
 gold 81, 83, 85, 86

hulug 27
silver 21, **37**, **56**, **62**, **64**, 65-67, **81**, 87
steatite 38
sumluk 27
bedu 14, 20, 28, 30, 36, 38, 58, 62, 65, 68, 85, 86
bells 20, 25, 46, 55, 59, 60, 64, 79, 81, 87, 88
bewiti 73
boxes (see also *hirz*) 20, 35, 51, 55
bracelets 14, 17, 19, 20, **21**, **22**, 25, **26**, 29, **35**, **41**, 43-45, **60**, 58-62, 59-61, 81, 82, 84, **86**, 87
 abu thalatha 62
 banajan 81,
 banajiri 61, 81
 hajala 61
 hayyiy 61
 malnaut 82, 85
 manaynah 87
 mhadabit 82, 87
 sukaylit 87
bridal jewellery 28, 29, 32, 45, 60, 83
Bronze Age 38, 45
brooches 34, 80
buckles 16, **70**, 73

buwdaqhan see rings
Byzantium 13, 19
carnelian 12, 19, 23, 36, 37, 38
Carthage Treasure 66
casting 40, 73
chainwork 28, 40, 65
 manjad 84, 85
 silsila 84
chasing 17, 18, 40, 41, 48
China 12, 20, 38, 43
cire-perdue 40
coffee pots 51, 53, **54**
coins (see also Maria Theresa thaler) **29**, 31, 32, 34, 47, 49, **54**, 55, 57, 58, 64, 65, 80, 81, 88, 90
copper 12, 61
coral 36, 37, 38
cowrie shells 22
craftsmen
 goldsmiths 23, 80, 82
 Jewish 22, 43, 82
 metal-workers 13, 14, 35
 silversmiths 14, **40**, 33, 65, 73, 80, 82
Croesus 32
daggers see *khanjars*
danglers **13**, **41**, **44**, 45, 46, 49, 54, 56,

57, 62, 63, 64, 65, 82, **83**, 90, 92
Dhofar 19, 27, 30, 38, 56-58, 62, 79-92
Dilmun 22
Doe, Brian 85, 92
dowry 28
ear-cleaners 51
ear-rings **13, 14**, 19, 20, **29**, 34, 62, 86,
 87, 88
 durrur **29**
 halaq 45, **62**
 lamiyah 45, **62,** 63, 64, 81, 82, 83
 mishill 63
 shaghab 62
Egypt 11, 12, 13, 17, 18, 19, 24, 31, 36,
 37, 38, 44-46, 53, 56-59, 82, 85
Elam 11
embossing 18, 40, 41
Empty Quarter 12
engraving 17, 40-42
Etruscans 19, 24
Evil Eye 22, 24, 26, 55, 85, 91
fertility symbols 23, 24, 45, 84, **90**, 91
filigree 17, 18, 42
frankincense 12, 13, 38, 53
funerary equipment 24
fusing 39
garnet 36
Ghaibun 85
gilding 42
gizail see guns
glass 24, 31, 36, 37, 38, 67, 68

gold
 leaf 17, 33, 61
 jewellery 19
 red 35
 refining 36
granulation 17, 18, 19, 39, 45, 68, 82, 85
Greeks 19, 27, 37, 66
gunpowder 78
guns 51, 75-78
 gizail 75
habbiyah 58
Hadramaut 12, 79, 85
hair decoration 64, 81, 88-90,
 athqul 88, **90**
haisa see rings
hajala see bracelets
Hajazi, women 59
hajal see anklets
halaq see ear-rings
hallmarking 33
Hand of Fatimah 45, 46, 62
hanhoun see necklaces
harf see head-dress
hayyiy see bracelets
head-dress 29, 88, 90, 91
 al kumma 65, 91
 harf **63**
 kharaka **89**
 lihaf 91
 saffia 90
 sils (muthalatha) **90,** 91

uqaam **65**
hegab see amulets
hirz 27, 43, 55, 56, 80, 84
hulug see beads
Hunter, F.M. 80, 81, 82
Huraidah 85
Ibri 16, 43, 61
incense 12, 13, 53, 79
incense burners 42, **50**, 51, 53, 54
India 14, 35
Iran 14, 44, 61, 82
ivory 12, 23, 38, 71
jabiyrah see rings 67
Jabrin 64
jerz see Shihuh axe
Jordan 57
kalada see necklaces
khalkhal see anklets
khanjars 16, 69-74, 80, 84
kharaka see head-dress
khatim abu fuss see rings
khatim abu saith see rings
khawatim see rings
khizam see rings
King Zer 17
kirdan 59
kitarah see swords
knives 69, 71
 sikeen 71
Knot of Hercules diadem 66
kohl 53

containers **15, 25,** 51, **52,** 87, **93**
Koranic inscriptions 26, 35, 55, 56, 81
lak beetle 57
lakdani see necklaces
lamiyah see ear-rings
lapis lazuli **18,** 19, 35, 38
lihaf see head-dress
Ma'in 12, 19
mafraq see head-dress
Magan 12
magic see *Zar*
makhal **53,** 53
maknak see necklaces
malnaut see bracelets
manaynah see bracelets
manthura 56, 59
marabba see rings
Maria Theresa thaler 32, 33, 47, 48, 49, 56
marriya see necklaces
marriya shnaf see necklaces
Martini Henry see guns
Matrah 16, 36, 47, 53, 78
mazrad see necklaces
mdharba 73
medallions 30, 56, 82
 sumt 30, 47
mercury 27
Mesopotamia 11, 12, 17, 44, 56
mhadabit see bracelets
mirtasha **58,** 59
mirwad 53

mishill see ear-rings
mulberry decoration **32,** 33, **42,** 45, **62,**
 67, 87
murjan see coral
Muscat 53, 78
muthalatha see head-dress
necklaces 55, 57, 84
 hanhoun 56
 kalada **29**
 lakdani 56
 marriya 80, 83, 84, 85
 marriya shnaf 29
 mazrad 47
 qursh makanna 47
 sumt mukahhal 56
Nizwa 16, 43, 54, 60
Oxus Treasure 20, 44, 45, 82
padink see anklets
Palestine 90
pearls **34,** 36, 58, 80, 81
pendants 14, 19, 20, 23, 26, 34, 44, **62,**
 66, 80,85, 88, 92
Periplus of the Erythrean Sea 12, 37
Persia 13, 20, 34, 45, 69, 78
Phoenicians 19
phylacteries see *hirz*
piercing 17
planishing 42
Pliny 12
Portuguese 75
powder horn (*talahiq*) 51, 78

qara 78
qaf 28, 29, 66, 83
qara see powder horn
Queen Bilkis 19
qursh makanna see necklace
rai 65
refining 36
repoussé 18, 41
rings: 21, 28, 59, 66
 buwlaghan 68
 finger 21, **33, 36,** 37, 81-92
 haisa 67
 jabiyrah 67
 khatim abu fuss 67
 khatim abu saith 67
 khawatim 66
 khizam 68
 neck 57
 nose *(badlah)* 29, 62, **68,** 80-84, 92
 shahid 66
 toe 21, **66,** 67, 81-84, 91, 92
 Zar **32,** 68
 wedding 22
Romans 36, 37, 85
rosewater sprinklers 51, 53
Rostaq 44, 60, 62
Royal Family see Al bu Said
saffia see head-dress
saif see swords
Salalah 79, 80, 82, 85
Sassanian empire 13, 20

Saudi Arabia 36, 38
scarab 18, 24
shabka see head-dress
shahid see rings
shaqhab see ear-rings
Sharqiyah 16, 33, 44, 55, 57, 61, 62, 71
Shihuh axe 74, 75
shodabiya see rings
sikeen see knives
sils see head-dress
silsila see chainwork
Sohar 78
soldering 39
spices 12
Stark, Freya 27, 85
stones 12
 precious 34
 semi-precious 31
sukayliyt see bracelets
sumluk see beads
sumt see medallions
sumt mukahhal see necklaces
Sur 33, 60, 61, 71, 80
swords (see also *khanjars*) 69-74
 kitarah 74
 saif 74
Syria 12, 58
talahiq see power horn
tawq 57
thaler see Maria Theresa
thorn-picks **15**, 16, 51, **52**
Thumrait 58, 62

tooth-picks **32**, 51
trade routes 12, 13, 20, 24, 38, 44
turquoise 19, 36, 38
Tutankhamun 18
tweezers **15**, 51, **52**
Ud 54
Umm an Nar 12, 43
uqaam see head-dress
Ur 12, 45, 66
weil see anklets
Yemen 13, 19, 36, 44, 57, 57, 82, 85
Zanzibar 12, 13
Zar see rings
zuqar see rings (toe)